Turner

Turner

William Gaunt

with notes by Robin Hamlyn

Phaidon · Oxford

Phaidon Press Limited, Musterlin House, Jordan Hill Road, Oxford OX2 8DP

First published 1971
This edition, revised and enlarged, first published 1981
Fourth impression 1989
© Phaidon Press 1981

A CIP catalog record for this book is available from the Library of Congress

ISBN 0 8230 5471 3

Printed in Portugal by Printer Portuguesa, Lisbon

The publishers wish to thank all private owners, museums, galleries and other
institutions for permission to reproduce works in their collections.
Particular acknowledgement is made for the following:
Fig. 10 – reproduced by courtesy of the Trustees of the Cecil Higgins Art
Gallery, Bedford; Plate 43 – reproduced by courtesy of the Museum of Fine
Arts, Boston, Henry Lillie Pierce Fund 99, 22; Plates 14, 15, 18, 20, 24, 34, and
Figs. 7, 19, 23, 24, 27, 28, 30, 32, 34 – reproduced by courtesy of the Trustees
of the British Museum; Plates 4, 11, 27, 28, 32, 39, 41, 46 and Fig. 3 –
reproduced by courtesy of the Trustees of the National Gallery, London; Plates
6, 21, 47 and Figs. 1, 5, 8, 12, 13, 16, 21, 22, 29, 35, 36, 38 – reproduced by
courtesy of the Trustees of the Tate Gallery, London. Fig. 17 – Reproduced by
permission of the National Gallery of Victoria, Melbourne.

Turner

There is no more extraordinary instance of a great artist's evolution than that of Joseph Mallord William Turner (1775-1851). Brought up within the confines of the neat topographical tradition of English water-colour, he left its limits far behind to soar into the realms of visual poetry and abstraction. By a kind of metamorphosis the young author of tinted architectural drawings in the style of the late eighteenth century turned into the colourist whose magic conjured up visions of sumptuous iridescence; the creator of tremendous images of fatality; the very genius of the 'elements', in the old philosophical definition of earth, air, water and fire.

It was a double — and might even be regarded as a triple — evolution. Throughout his career, Turner practised both oil and watercolour painting and the range of his achievement in the one medium was matched in the other. A third aspect is to be observed in the difference between finished works in either medium intended for exhibition, or sold directly to his patrons, and those produced purely for his own satisfaction, by way of experiment or in watercolour as a record of some effect of light, cloud or time of day noted in the course of his travels.

In the 'considered' compositions such as he exhibited at the Royal Academy (e.g. Plates 4, 11 or 27) something of the development of his thought and general attitude to life may be traced in his choice of subject. The other works not shown in public, the canvases stacked in his London house, the piles of drawings and sketchbooks, have since revealed the astonishing extent of his research into the properties of light and colour, the technical resource and daring he increasingly displayed, the expressive freedom that accompanied his habit of close observation.

There was never any doubt of his vocation from the time his childhood drawings were proudly exhibited by his father in the window of his hairdresser's shop in Maiden Lane and won words of praise from artist-customers who lived in the then artists' quarter of neighbouring St Martin's Lane. When Turner entered the Royal Academy Schools at the age of fourteen, what may be called the discovery of Britain was in full swing. An awakened interest in the past called for pictures of castles, abbey ruins, Gothic churches, old buildings of village and town in picturesque decay.

It was a genre that offered steady employment not only in the production of originals for individual patrons but also in supplying drawings from which engravings could be made for the illustrated publications then in vogue. Diligently applying himself to this specialization, Turner had early success; by the time he was 24 he had more commissions than he could execute. Trained in topographical accuracy by Thomas Malton,

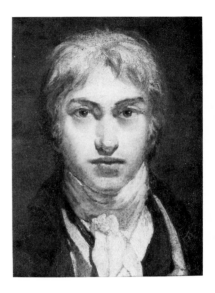

Fig. 1 Detail from Self-Portrait

CANVAS, 74.5 x 58.5 CM. C. 1798. LONDON, TATE GALLERY

junior, specialist in town architecture with incidental figures, he was soon the master of an acceptable style, as capable as any of conveying the picturesqueness of the pointed arch, the ruined cloister.

The evenings he spent at Adelphi Terrace in the house of Dr. Thomas Monro, collector and amateur artist, as well as physician, copying or filling in the outlines of unfinished drawings by J. R. Cozens, may well have helped to widen his outlook. Cozens — whose watercolours John Constable described as 'all poetry' — suggested grandeurs of height and space in his Alpine and Italian views that went beyond topographical requirements. Turner's friend and co-worker in the evening sessions, Thomas Girtin, also had ideas to impart — of watercolour no longer timidly grey and dependent on outline but with a strength of colour that would not look insignificant when compared with oil painting. Girtin, too, was bold in treatment of space. 'Had Girtin lived, I should have starved' was Turner's characteristically odd way of saying that he had profited by the example of his short-lived artist friend, who up to that point was in some ways ahead of him.

A beautiful example of Turner's early style of watercolour is the *South View of Christ Church from the Meadows* (Plate 3), painted for the *Oxford Almanack* of 1799, one of the ten watercolours he made for the *Almanack* at various dates. The delicately tinted grey washes, the detail put in with a pen, as well as possessing a restrained charm, were calculated to guide the engraver in tone and line. Yet this is a late example of his early manner. Already he meditated more vivid and powerful effects and his ambitions were not confined to watercolour.

Fishermen at Sea (Fig. 16), hung in the Academy of 1796, was his first exhibited oil painting which attracted critical notice as proof of an original mind. There is reason to identify it with the *Cholmeley Sea Piece,* long in the possession of the Cholmeley family of Bransby Hall, Yorkshire, and bought by the Tate Gallery in 1972. A second sea piece, *Fishermen coming Ashore at Sunset Previous to a Gale,* exhibited in the Academy of 1797, was again favourably noticed. Though the picture has not been traced, contemporary descriptions suggest it foreshadowed Turner's greatness as a painter of the sea.

The small oil *Moonlight. A Study at Millbank* (Plate 1), also exhibited in 1797, brings to mind the 'moonlights' of the seventeenth-century Dutch painter Aert van der Neer, and seems to indicate that he had already begun to study continental ways of looking at nature. He paid attention to the style and type of subject of various masters. But the study of nature was paramount. The heaving waters of the early sea pictures that so impressed his contemporaries were no doubt the result of observation on stormy days at Margate (his favourite coastal resort) or during his visit to the Isle of Wight in 1795. The sketchbooks in the Turner Bequest indicate the surprising extent of his travels in Britain which, before 1802, took him to a hundred places — Wales, north and south,

the Lake District, Yorkshire, Scotland, and the midland and southern counties. Travel of this kind was essential to the topographer in search of the picturesque remnants of the past, though in Turner's insular grand tour (he left only Ireland unvisited) he inevitably made acquaintance with nature in every mood.

From 1793, when war was declared between France and England, and continental Europe was virtually out of bounds, the English landscape painter was perforce limited to the English scene. For those with a strong local attachment this was far from being a hardship. John Constable, close to Turner in age but very different in temperament and outlook, was quite content with his native fields and skies and had not the least wish to go abroad. With Turner, on the contrary, the nomadic habit and the desire for fresh experience were already ingrained. Directly the Treaty of Amiens was signed in 1802, he was off on the Channel boat from Dover to Calais *en route* for a journey through France and Switzerland. The superb *Calais Pier with French Poissards* [sic] *Preparing for Sea: an English Packet Arriving* (Plate 4) was a result of the voyage and was exhibited in the following year.

The movement throughout the composition, the contrast between the dark rain clouds and the patch of clear blue sky, the vortex of sea, painted with a vigour surely never before seen in art, the varied angles of masts and sails, the excitement of the groups of figures, the sparkle of such detail as the fish on the jetty, combine to make *Calais Pier* a great picture. His devoted admirer, John Ruskin, termed it 'the first which bears the sign manual and sign mental of Turner's colossal power', though it would be possible to assign this priority to the beautiful *Buttermere Lake* of 1798 (Plate 2). The emergence of his individual genius corresponds in date with the Romanticism of the new century, the growing taste for violent and spectacular effect, the experience of nature in its wildest and most awesome moods. How romantically fascinated Turner was by the rage of the elements, with what pessimistic philosophy he viewed the defeats of man by fire, flood and tempest, a long sequence of dramatic works was to show.

The Shipwreck of 1805 intensified the drama of *Calais Pier* with its mountainous waves and vessels at precarious angles. *The Fall of an Avalanche in the Grisons* (Plate 7) of 1810 conveyed all the irresistible force of a huge boulder crashing down from the Alpine heights. The *Snow Storm: Hannibal and his Army Crossing the Alps* of 1812 (Plate 9) is vastly impressive in the way a whirlpool of atmosphere engulfs the small and dimly seen figures.

Yet in the same period, and until his first visit to Italy in 1819, he followed other, contrasting directions. There is the remarkable interlude between 1805 and 1810 when contrary to his usual practice he worked direct from nature in oils on the Thames between Walton and Windsor, painting from a boat in the fashion later adopted by Daubigny and

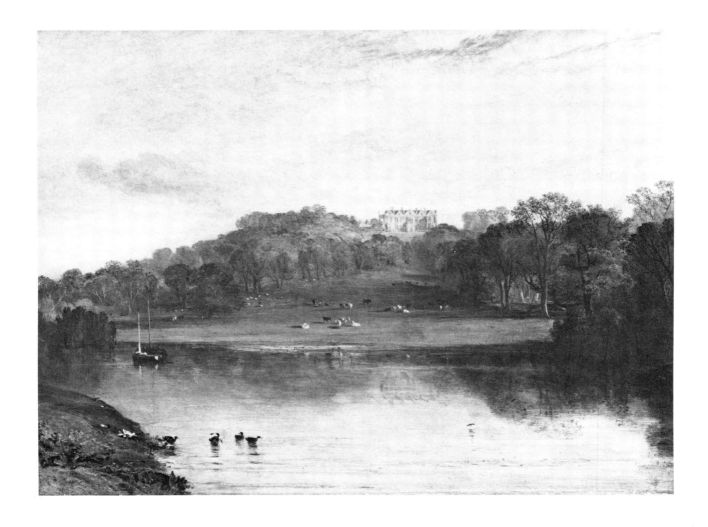

Fig. 2 Somer-Hill, near Tunbridge

CANVAS, 91.5 x 122.5 CM. EXHIBITED 1811.
EDINBURGH, NATIONAL GALLERY OF SCOTLAND

Monet on the Seine and Oise. The authentic atmosphere, the cool serenity and absence of any artificial contrivance in his sketch of *The Thames near Walton Bridges* (Plate 5) anticipates the freshness of Constable's oil sketches. It is only in this and works of the same period executed in a similar fashion that Turner gives evidence of any point of contact with his contemporary and great complement in landscape.

Tranquil and natural in its evocation of evening light is his version of the 'country house portrait' *Somer-Hill*, exhibited 1811. (Fig. 2. Edinburgh, National Gallery of Scotland), with just so much detail of browsing cattle and foreground water-fowl as completes the composition without disturbing its quietude. But in an entirely different vein are the several paintings executed in the manner of Old Masters he admired: Claude Lorrain especially, but Nicolas Poussin also, and, among the seventeenth-century Dutch painters, Cuyp and van de Velde.

Claude was a favourite with English collectors and Turner had seen and admired examples in the house of William Beckford and elsewhere before he went to France in 1802 and was able to study pictures in the Louvre. The Paris visit, however, probably made him more inclined

to finish his education by painting after the manner of the classics of landscape art. It is reasonable to suppose that artists learn more about painting from the study of pictures than the study of nature. It need not be assumed that Turner aimed to demonstrate that everything that had been done he could do better. Nor can he be said to excel Claude in pictures of sunrise or sunset casting their gleams on the fancifully imagined ports of ancient times.

His wish that his *Dido Building Carthage* (Plate 11) and the *Sun Rising through Vapour* (Fig. 3. London, National Gallery) should hang near Claude's *Embarkation of the Queen of Sheba,* for a long time disregarded at the National Gallery but now respected, provides a comparison that favours Claude, whether in terms of clarity of composition, the quality of tone and colour or the accessory details. The sky of *Dido Building Carthage* seems harshly yellow when compared with the mellow tone of the *Embarkation.* In the same year, 1815, Turner exhibited another elaborate tour-de-force in *Crossing the Brook* (Plate 12), a view down the valley of the Tamar towards Plymouth, which, like the Carthaginian picture, aroused much popular enthusiasm. The distance is wonderfully painted, the foliage richly intricate, the composition perfectly planned. If the picture has a slight discrepancy, it is in the 'classical landscape' character that imposes an alien sophistication on an English scene.

Fig. 3 Sun Rising through Vapour: Fishermen Cleaning and Selling Fish

CANVAS, 134.5 x 179 CM. EXHIBITED 1807. LONDON, NATIONAL GALLERY

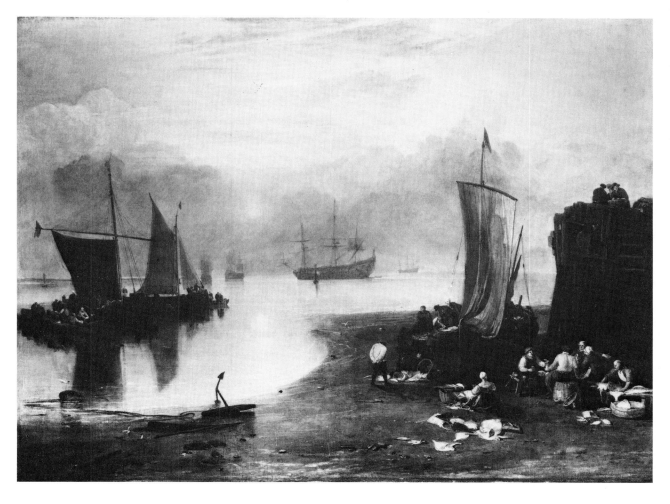

The sumptuous artifice of the two main exhibits of 1815 may not perhaps so directly elicit the spectator's sympathy as Turner's periodic return to simplicity, of which *Frosty Morning* (1813: Plate 10) is a superb instance. It is a concentration of atmosphere, the few figures, horses and cart and agricultural properties in a featureless and frozen lane, having no story to tell save that it is a cold early morning in Yorkshire. With a breadth that recalls the work of Crome, Turner conveys a feeling of reality made the more impressive to the present-day observer by recent cleaning which has removed the falsifying effect of yellowed varnish and disclosed the delicate grey of rime.

When the Napoleonic War was over, Turner had still to see Italy for the first time. It was an indication of his success that he was prevented for a while by the demands of the engravers for drawings. In 1817 a short visit to Belgium (to see the battlefield of Waterloo) and to Holland and the Rhine Valley produced a series of Rhine watercolours and in 1818 a magnificent souvenir of the Netherlands in the *Dort, or Dordrecht, the Dort Packet-Boat from Rotterdam Becalmed* (Plate 13), which Constable described as 'the most complete work of genius' he had ever seen. Bought by Turner's friend and patron, Walter Fawkes, the picture long remained at Farnley Hall, the home of the Fawkes family in Yorkshire, where Turner was so often a welcome guest.

His first visit to Italy followed in 1819. He was now 44 and middle-age marks the beginning of a new stage in his career. Ruskin, arbitrarily dividing Turner's life into four periods, considered the first — that of 'studentship' — to extend until 1820. Allowing for a very broad definition of the word 'student', implying that Turner was 'trying not so much

Fig. 4 A Frontispiece: Fairfaxiana

WATERCOLOUR OVER PENCIL, WITH PEN AND
INK AND SOME SCRATCHING OUT, 18 x 24 CM.
1815. OXFORD, ASHMOLEAN MUSEUM (RUSKIN
SCHOOL COLLECTION)

10

to invent new things as to rival the old', the division has its point — as regards oil painting at all events. In watercolour, however, he had already shown an individual mastery of the medium, leading him first to elaborately finished effects obtained by a variety of technical devices and then to the greater freedom and liquidity of colour observable in the Rhine water-colours of 1817, a series bought by Walter Fawkes. An instance of his virtuosity is the rain cloud in his watercolour of Mainz, floated and allowed to spread on wet paper like the 'calculated accident' of a modern action painter.

The light of Italy was a revelation that was to illumine much of his later work. That he took to Venice at once may be gathered from the beautiful watercolours of 1819, evidently direct impressions set down with a remarkable certainty of technique and freshness of effect. There is all the purity of dawn atmosphere in his *Venice, Looking East from the Giudecca: Sunrise* (Plate 14) and the suffusion of light at a somewhat later hour of *San Giorgio from the Dogana* (Plate 15), achieved with an apparent simplicity by the wash of pure colour to which the white paper beneath adds luminosity. The watercolours made at Rome reverted to a denser texture of colour. Turner also made a large number of pencil sketches in both cities for reference later, needing only such slight reminders of detail and indications of compositions when he came to paint.

There is no doubt of the powerful impression Italy made on him. The Turner who liked to muse over the grandeurs or the decadence of the past was stimulated to monumental effort by Rome, though the painting exhibited in 1820, *Rome from the Vatican: Raffaelle,*

Fig. 5 Rome from the Vatican: Raffaelle, Accompanied by La Fornarina, Preparing his Pictures for the Decoration of the Loggia

CANVAS, 177 x 335.5 CM. EXHIBITED 1820. LONDON, TATE GALLERY

Fig. 6 Chateau of Amboise

WATERCOLOUR AND BODY-COLOUR WITH
PEN ON BLUE PAPER, 13.5 x 19 CM. C. 1826–30.
OXFORD, ASHMOLEAN MUSEUM

Accompanied by La Fornarina, Preparing his Pictures for the Decoration of the Loggia (Fig. 5) was as overcrowded and as near to absurdity of illustration as its lengthy title alone would suggest. The real value of the Italian influence was far different, an influence of light and colour that showed itself increasingly in his paintings during the 1820s.

A new vividness of tone tempers the traditional light and shade of *The Bay of Baiae, with Apollo and the Sibyl* (Plates 16 and 17), exhibited in 1823. It was in 1829, the year after his second visit to Italy, that he produced one of his major masterpieces, *Ulysses Deriding Polyphemus* (Plate 27), with its blaze of scarlet and gold tempered by blue and its wonderfully radiant morning sky. How the region round Naples inspired him may be gathered from the crags of the *Ulysses* and the *Rocky Bay with Figures* (Plate 31), a scene such as Salvator Rosa might have painted but here conceived in Turner's own style.

Most deeply felt of all was the inspiration of Venice, a lovely mirage as he saw it poised between the sky and water, and after his second and third visits, in 1835 and 1840, a main theme in both oil and watercolour. Meanwhile his work on other themes displayed an increasing freedom and technical variation, of which the products of his sojourns at Petworth provide the most astonishing examples. The death of Turner's father in 1829 was a heavy blow, which made it hard to spend long periods alone in the studio-house he occupied in Queen Anne Street. There Turner senior had busied himself with the exhibitions his son held from time to time in his own premises. He had been virtually a studio assistant as well as a parent with whom his son shared an understanding affection.

From this time Turner was more nomadic than ever, while the accumulated canvases and drawings at Queen Anne Street began to moulder in neglect and decay. It was a relief to stay at the country estate

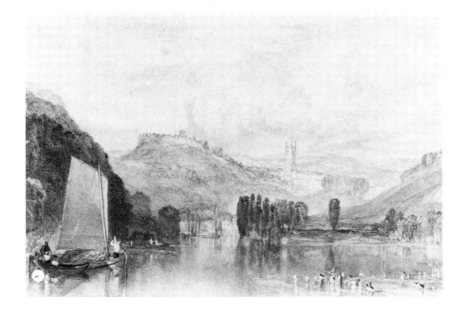

Fig. 7 Totnes, on the River Dart
WATERCOLOUR, 16 x 23 CM. C. 1824. LONDON, BRITISH MUSEUM

in Sussex where George Wyndham, the third Earl of Egremont, one of the first to appreciate and acquire Turner's work, always made him welcome. In what was almost a second home, where he had his own painting room, he took a fresh leap forward in his art. A sense of relaxation, of relief from care, pervades his *Petworth Park: Tillington Church in the Distance* (Plate 19), painted about 1828, the setting sun throwing a peaceful enchantment over the scene. On canvases of similar proportion, intended as a set to be fitted in panels in the Petworth dining-room, he painted in a similar spirit his views of *Chichester Canal* (Plate 21) and *The Chain Pier, Brighton* (Plate 22).

In the sympathetic atmosphere of Petworth he felt free to experiment in technique, to dispense with any idea of what others might approve or disapprove. He had already — from about 1825 onwards — been producing works in bodycolour on blue paper (Fig. 6). destined to be engraved as *The Rivers of France* in the three separate series of *Turner's Annual Tour*, 1833, 1834 and 1835. They were a sequel to the *Rivers of England* series of 1825, but differed from the finished watercolours he had previously done in that they gave scope for the suggestion of atmosphere. The blue-grey ground, often only slightly modified by added paint, led Turner to employ cooler colour schemes than usual without those sharp touches of vermilion and bright yellow to which he was addicted. The scheme that gives so distinct a beauty to his gouaches of the Loire was used again with extraordinary effect in the sketches of interiors at Petworth in the same medium (Plates 20 and 24). Without outline and with a pastel softness of light and summary indication of darker tone, these gouache interiors are among the most captivating products of his art.

In oils, without attempting to transfer to canvas the soft blues and pinks of the gouaches, he also sought a generalized effect. It is made less

13

emphatic by the presence of the figures in the painting of a music party at Petworth (now in the Tate Gallery), but becomes a breathtaking outburst of colour in the most remarkable of all the Petworth paintings, the *Interior* in oils of c. 1837 (Plate 40). The description 'impressionist', which might be applied to some of the gouaches, would here be out of place; 'expressionist' is a fitting word to use of its violence of red and gold, its exuberant streams of light and chaos of objects, as if light had turned into a flood on which the magnificent wreckage of furniture had gone afloat.

Perhaps Turner wished to express in the abstraction of the *Interior* his delight in the spaciousness of the house and the informality of the household. But the mood of Petworth was followed by varied directions of effort. The first of his oil paintings of Venice was exhibited at the Academy in 1833, the *Bridge of Sighs, Ducal Palace and Custom House, Canaletti* [sic] *Painting* (Fig. 8). The introduction of 'Canaletti' at his easel indicates his respect for the Venetian master, though Turner followed him in subject matter rather than style. This and the Venice painting of the following year, the *Venice* (Plate 33) were as highly finished as public exhibition made politic, but in vividness of light and colour were conceived in a different key from Canaletto's *vedute*.

The elemental fury which never failed to excite him was irresistibly combined with the topical event in the destruction of the Houses of Parliament by fire in 1834, soon after he had returned to London from Petworth. Flitting from point to point on either side of the Thames on the night of the fire on October 16, he gorged his vision on the splendour of flame, making the while swift pictorial notes in watercolour in his sketchbook (e.g. Plate 34). Two paintings of the scene were exhibited in the following year, particularly impressive being the version now at Cleveland, Ohio (Plate 35). The huge red and yellow pattern, formed by the fire and its reflection in the Thames, made the boldest of designs in contrast with the surrounding dark blue of night, though river, boats and sky outside the conflagration area were enlivened by sparkles of silver light.

As a nocturne, it had its complement in the same exhibition in a reminiscence of the Tyne, *Keelmen Heaving in Coals by Night* (Plate 37), a highly original composition in which the ships and their flares of artificial light are on the outer edge and the central space of water is left empty to receive the unimpeded radiance of the moon. There is no exact date for that other great picture of this period, *Fire at Sea* (Plate 38), which was not exhibited in his lifetime, but it may possibly have followed quickly after the Westminister fire. The triumph of wild nature over man, the theme he struggled so hard to put into words in the fragments of his poem on *Fallacies of Hope,* was celebrated in the formidable moves and countermoves of sea and sky in *Fire at Sea,* while the gouts of burning matter whirled into the air take on the illusive splendour of a golden

shower. Yet it was probably about this time that he could apply himself in contrast to so tranquil a scene of calm after storm, so concerted a harmony between sky, sea and shore as that of *The Evening Star* (Plate 32).

On his second and third visits to Venice in 1835 and 1840 he continued to use watercolour in the style of the gouaches for the *Rivers of France* and the sketches at Petworth, with additional liberties of technique. As on the night of the fire at Westminister, he seems to have departed from his usual practice by painting on the spot in watercolour direct from the scene before him. Venice by night, thus seen from his hotel window, became more than ever dream-like in works on blue-grey or brown paper, executed in mixtures of watercolour, bodycolour, pen and chalk. He had long before ceased to produce watercolours for exhibition. Made for his own satisfaction, the superb studies, of a rocket curving above the palaces shrouded in darkness, of the lagoon simply as an expanse of coloured space, or the palaces and churches as a golden glow, herald the final period in which — among his most marvellous creations — are the visions of Swiss towns and lakes and the Rhine; of Lucerne, Constance, Interlaken, and Heidelberg (Plate 48). From 1840 to 1844 on his summer journeys to Switzerland, each year he seemed to find, Ruskin observed, 'new strength and pleasure among the scenes which had first formed his power'.

While Ruskin could appreciate the watercolours of this late period, he stated that the last oil picture that Turner 'ever executed with his perfect power' was *The Fighting 'Temeraire'* of 1839 (Plate 41). He supported this judgement by reference to the workmanship. It was the last picture, he

Fig. 8 Bridge of Sighs, Ducal Palace and Custom-House, Venice: Canaletti *(sic)* Painting

OIL ON MAHOGANY, 51 x 82.5 CM. EXHIBITED 1833. LONDON, TATE GALLERY

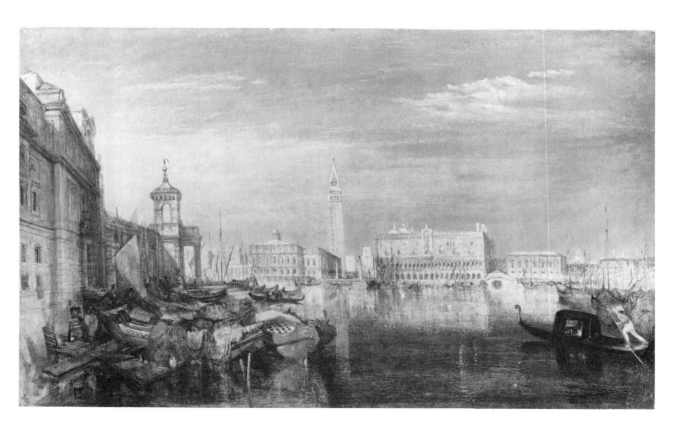

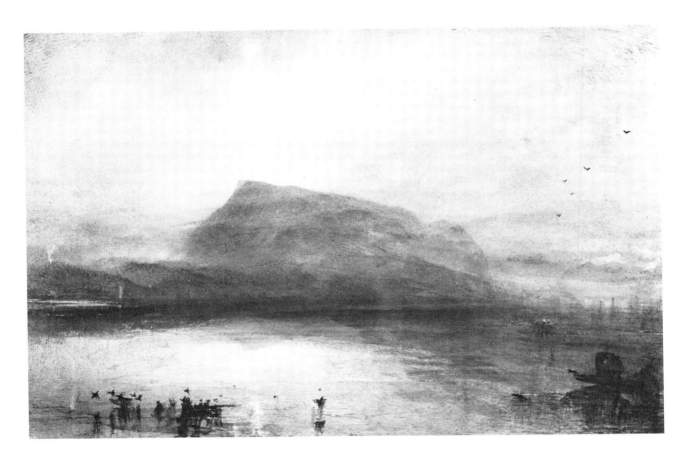

Fig. 9 The Blue Rigi: Lake of
Lucerne, Sunrise

WATERCOLOUR, 29.5 x 45 CM. 1842. PRIVATE
COLLECTION

said, in which Turner's execution was 'as firm and faultless as in middle life; the last in which lines requiring exquisite precision such as those of the masts and yards of shipping are drawn rightly and at once'. The reason given is not altogether convincing. The critic was perhaps too fanciful in further observing that *Ulysses Deriding Polyphemus* and *The Fighting 'Temeraire'* symbolized the course of Turner's career, the one representing sunrise, the other sunset, 'unconsciously illustrative of his own life in its decline'.

What the picture more obviously conveys is the passing of an era. It was a last reminder of the Napoleonic war at sea on which, while it was still in progress, Turner had made his own pictorial commentary. He had been over the *Victory* and noted down sailors' eye-witness descriptions to prepare his painting of *The Battle of Trafalgar, as Seen from the Mizen Starboard Shrouds of the Victory* (Fig.36) exhibited at the British Institution in 1808. The seizure of the Danish fleet as a precaution while invasion was still a threat provided the picture of two captured Danish ships entering Portsmouth harbour, shown in the same exhibition. George IV had commissioned another *Trafalgar* in 1823 as one of a series of great battles by land and sea to be hung in St. James's Palace, though it was the subject of various nautical criticisms from naval officers, and consigned to Greenwich Hospital.

These were patriotic by-products of Turner's art which hardly

concern his aesthetic progress, but evidently he had an affection for the 'wooden walls' he knew as well, as witness the watercolour of a 'first-rate taking in stores' (Fig. 10), which he drew from memory in 1818 to show the size of a man o' war, when he was staying at Farnley Hall, while Walter Fawkes's son looked on in wonder at his skill. No doubt affection was tinged with sadness, or a sense of melancholy in the occasion, when he came to paint the veteran of Trafalgar—that had earned the name of the 'fighting *Temeraire*'—being towed from Sheerness to Rotherhithe in 1838 to be broken up. In a wider sense it marked not only the passing of an age but the advent of a new one in the contrast between the almost phantom sailing ship and the steam tug belching forth its dark cloud of smoke.

It may be remarked that Turner was not one to shut his eyes to change or to show that aversion to the industrial revolution and the age of steam that was so strongly felt by his champion, Ruskin. In his attitude to art and life there was an admixture of the romantic and the realist. As late as 1837 he could still go romantically back into a legendary past in *The Parting of Hero and Leander* (Plate 38), which is like a Wagnerian opera in paint, with its overweight of grandiose theatre and yet a solemnity of colour, in the deep tones of sky, shore and sea, that is of real magnificence. At the same time, he was equally ready to paint the lurid glow of blast furnaces on the outskirts of Birmingham. It caused him no pain to

Fig. 10 A First Rate Taking in
 Stores

PENCIL AND WATERCOLOUR, 28.5 x 39.5 CM. 1818.
BEDFORD, CECIL HIGGINS ART GALLERY

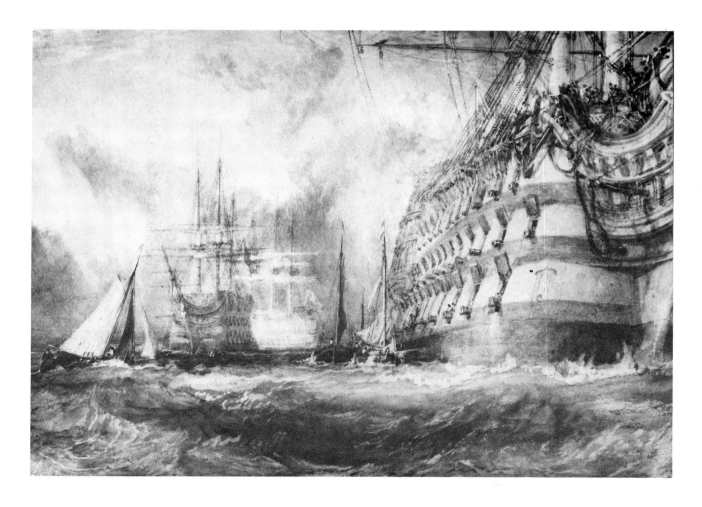

substitute new methods of transport as features of a landscape or sea-scape in place of the picturesqueness of packet-boat or stage-coach.

An instance is given in 1831 when he went to Scotland to discuss illustrations with Sir Walter Scott for the projected complete edition of Scott's poems. On leaving Abbotsford he travelled by steamer from Edinburgh to Stirling, by steamer again through the Crinan Canal to Oban and the Isle of Skye and again by steamer, the *Maid of Morven*, to visit Staffa and Iona. A letter written in his laconic and elliptical style described the hazards of getting into Fingal's Cave, by which he was undeterred, as the vignette for *The Lord of the Isles* indicates by showing the interior of the cave looking towards the entrance. Stormy weather caused the passengers to vote against going on to Iona. 'The sun getting towards the horizon', says Turner, 'burst through the rain-cloud, angry, and for wind; and so it proved, for we were driven for shelter into Loch Ulver, and did not get back to Tobermoray [sic] before midnight.'

The *Maid of Morven* in the oil painting of the following year, *Staffa, Fingal's Cave* (Fig.11) is a majestic adjunct to a pictured state of weather that bears out the verbal description. The trail of smoke from the tall funnel merges into the vapour of storm cloud, nature and machine come into accord. The zest of observation continued long after the time when Ruskin pictured him as being in his decline. In 1839, when the *Temeraire* was painted, Turner was a vigorous 64 and had still to take some of his most daring flights and produce some of his most memorable works.

They were still of two kinds: the works that featured in public exhibition and the others, privately retained, of uninhibited freedom, though in his later years Turner was comparatively indifferent to the prudent consideration of what the public might or might not like — for example, *The Slave Ship*, exhibited at the Academy in 1840, under the title *Slavers Throwing overboard the Dead and Dying — Typhon* [sic] *Coming on* (Plate 43). The tragedy of the human situation was again his theme, though to a dispassionately aesthetic judgement it might appeal foremost as a marvellous painting of sea. It was thus that the young Ruskin, who met Turner for the first time in this year, viewed it, pronouncing it 'the noblest sea that Turner has ever painted' in the first volume of *Modern Painters*.

Ruskin senior acquired the *Slave Ship* to give to his son, but much as the latter admired the painting of the troubled waters, the spectacle of the manacled slaves thrown overboard and sinking in the shark-infested and otherwise sinister ocean proved too disturbing. He sold the picture after his father's death.

In 1842 Turner exhibited one of his greatest renderings of the rage of the elements, the *Snowstorm*. His fondness was for circumstantial detail in his titles and he added *Steamboat off a Harbour's Mouth Making Signals in Shallow Water and Going by the Lead* (Plate 45). There was a touch of pride (as well there might be) in the accompanying note in the Academy

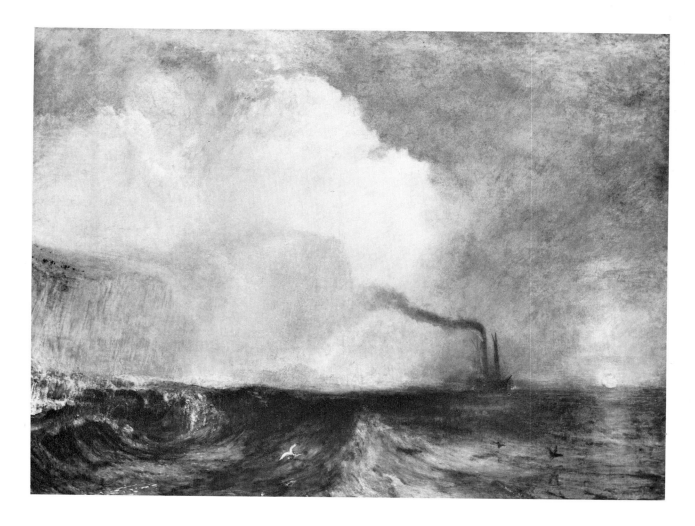

Fig. 11 Staffa, Fingal's Cave

CANVAS, 91.5 x 122 CM. EXHIBITED 1832.
NEW HAVEN, CONNECTICUT, YALE CENTER FOR
BRITISH ART (PAUL MELLON COLLECTION)

catalogue. 'The author was in this storm on the night the *Ariel* left Harwich'. The heaving waves, the dizzying vortex of storm cloud, the rifts that allow a brief glimpse of blue sky, contribute to the feeling of wild and irresistible movement. Turner was the better able to convey its reality from the four hours during which, at his request, he was lashed to the mast. The intrepid artist of sixty-seven by his own account "did not expect to escape but I felt bound to record it if I did".

In the same exhibition was hung the picture of the burial of Sir David Wilkie under the title *Peace – Burial at Sea* (Plate 44). The year before, on his way back via Egypt from his journey to Palestine, Wilkie had been taken ill on board ship and died when the vessel was off Gibraltar. Landing was refused because of quarantine. The ship's carpenter made a coffin and at half-past eight in the evening by the steamer's log, the painter's body was lowered into the sea. This was the scene Turner had to imagine from the accounts given. The painting is one of his best-known and perhaps least popular. Its severe contrasts and the density of black were adversely remarked on by contemporary critics. Yet this was an intended vehemence in which the 'expressionist' side of Turner's art appears. Not

otherwise could he have given an emotional value to his treatment of the subject—as may be gathered from his reply to Clarkson Stanfield, who complained about the blackness of the steamer's sails: 'I only wish I had any colour to make them blacker!'

A superb masterpiece among the exhibited pictures was still to come, *Rain, Steam and Speed,* hung in the Academy of 1844 (Plate 46). It was as little conventional and as purely expressive as any of the works he did not choose to show publicly. At this late period he was indifferent to the bewilderment or indignation caused by what the *Spectator* termed a 'laxity of form and licence of effect . . .greater than people will allow'. Like the *Snowstorm,* the picture was the vivid translation of a personal experience. Leaning out of his railway carriage window Turner was once again absorbed in the action of elemental forces, the enjoyable excitement of driving rain, the rush of movement accompanied by showers of soot and sparks from the engine, the momentary glimpse of wooded slopes and misty distance. He conveys all this, though transferring himself to another viewpoint, the speed of the advancing locomotive being accelerated in effect by the widening perspective of the bridge it is to cross, as well as by the flying strokes of the brush.

His versatility remained as prodigious as ever. A number of enchanting oils as well as watercolours followed his journey to Venice in 1840. Ruskin, who nowhere makes mention of *Rain, Steam and Speed* (possibly because of his intense dislike of railways) considered *The Sun of Venice going to Sea* (1843) one of Turner's leading works in oil. Yet when he wrote his Notes on the Turner Bequest, he also remarked on signs of deterioration in the paint which now sadly interferes with appraisal of the picture as one sees it in the Tate Gallery.

It cannot be said that in his final period of activity Turner lost all interest in subject. Imagined wonders of the deep were evidently much in his mind about the time he painted *The Slave Ship* with its strange specimens of fish clustering round a drowning slave. *Sunrise with Sea Monsters* (Plate 47) places grotesque forms in an expanse of light. A number of whaling scenes in the Academy exhibitions of 1845 and 1846 acknowledge a literary source—Thomas Beale's *Natural History of the Sperm Whale* apparently made him think of these Arctic scenes. He experimented in imaginative themes. In his weirdly impressive picture of a skeleton rider (Plate 29), he might well have been thinking of Benjamin West's *Death on a Pale Horse,* a pioneer composition of the High Romantic kind. An effort to follow Goethe's anti-Newtonian Theory of Light and Colour is marked by the contrasts of light and dark in the picture in the Tate Gallery, *Light and Colour (Goethe's Theory) – The Morning after the Deluge – Moses Writing the Book of Genesis. The Angel Standing in the Sun* (Fig.13), of 1846, was a venture into mysticism, more suited to the temperament and style of William Blake.

The essence of Turner's achievement in the later years is to be found

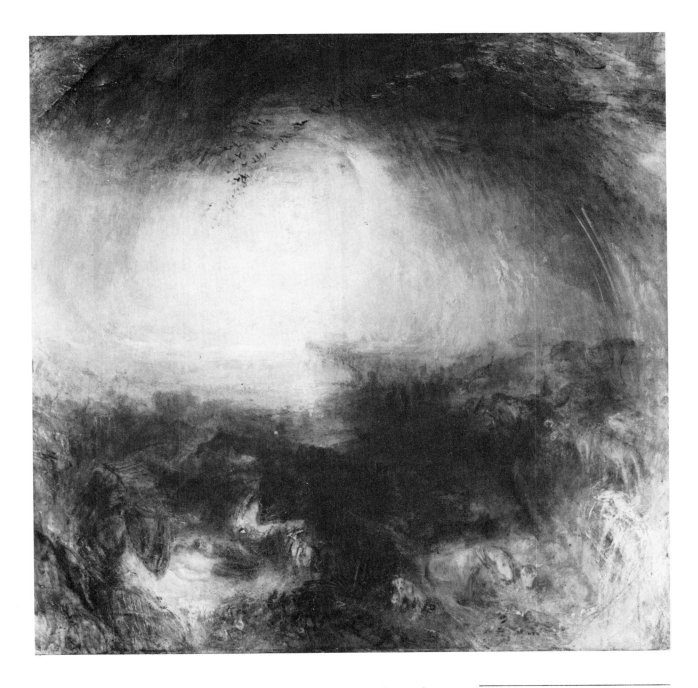

where subject is dissolved in space and light rather as modern science transforms matter into energy. The 'colour beginnings' of the sketch-books, the watercolour notes of storm cloud or sunset were suggestions of atmospheric and abstract effects of which he made brilliant use in both the well-known pictures of the later period and the rediscoveries made in the vast reservoir of his bequest to the nation, again brought to the light of day at the Tate Gallery.

The character of Turner remains somewhat enigmatic. No biography has given an entirely satisfactory picture of the man, and it seems

Fig. 12 Shade and Darkness – the
Evening of the Deluge

CANVAS, 78.5 x 78 CM. EXHIBITED 1843. LONDON,
TATE GALLERY

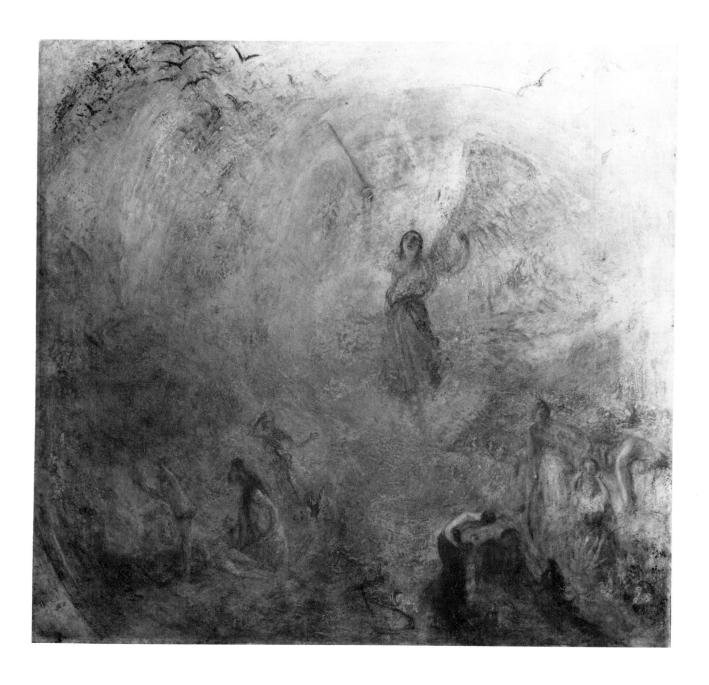

Fig. 13 The Angel Standing in the
Sun

CANVAS, 78.5 x 78.5 CM. EXHIBITED 1846. LONDON,
TATE GALLERY

doubtful whether such a biography could now be written. He has evidently
been much misrepresented, especially in the *Life* compiled by Walter
Thornbury ten years after Turner's death and the first to appear. Thorn-
bury repeated prejudiced ideas of Turner that had circulated in the
artist's lifetime — and added fictions of his own. One gets nearer to the
real Turner in Ruskin's impressions when they met for the first time in
1840. 'Everyone had described him to me as coarse, boorish, unintellec-
tual, vulgar. This', says Ruskin, 'I knew to be impossible. I found in him a
somewhat eccentric, keen-mannered, matter of fact, English-minded

gentleman . . yet sensitive at the same time.' His sensitiveness to poetry may be estimated from his discerning choice of the landscapes imagined by poets. Milton's *Paradise Lost* and Thomson's *Seasons,* works by Byron and Scott, aptly provided the appended quotations to his listed titles in the Royal Academy exhibition catalogues. His powers of mind that Ruskin observed to 'flash out occasionally in a word or a look' are not discounted by the fact that he himself was no poet in words, manfully though he struggled to give utterance to his mournful philosophy in passages of his *Fallacies of Hope.* His poetry of feeling flowed torrentially into the visual rather than the literary channel. He was often generous to his confreres while taking the trouble not to appear so. His loyalty appears in an almost filial attachment to the Royal Academy, where he was proud (if not always comprehensible to his audience) to be the Professor of Perspective. His strength of affection appears when his friend, the sculptor Sir Francis Chantrey, died. 'He wrung my hand, tears streaming from his eyes', records George Jones, who became his executor, then 'rushed from the house without uttering a word'. His patrons were also friends with whom he could stay as long as he wished, and though sensitiveness seems to have debarred him from visiting Farnley Hall or Petworth after Walter Fawkes and Lord Egremont had died, he left an agreeable memory at both houses. Hawksworth Fawkes, the 'Hawksy' who as a boy had watched entranced the evolution of the man o' war in his watercolour, never failed to send Turner a game pie and a brace of pheasants every December, down to the last year of the artist's life.

It is not difficult to dispel the mystery and innuendo which Thornbury attached to Turner's lodging in Chelsea and his regular visits to Wapping. At the age of 70 or over he probably found Queen Anne Street lonely and oppressive and sought a cosier alternative in the little cottage, 119 Cheyne Walk at Chelsea. Whether or not he had known the lady of the house, Mrs. Booth, at Margate in earlier days, he is more likely to have appreciated her motherly care than to have sought amorous adventure. He was admittedly secretive, but passing for Mr. Booth was quite possibly an expression merely of his odd humour and a wish not to be pointed out in the locality as 'the great painter'. As for Wapping — instead of 'wallowing', as Thornbury suggested, in whatever orgies it might provide—the plain fact is he had property there and went to Wapping to collect his rents. There was another reason for Chelsea. After 1845 he no longer went abroad or far from London. The observation post he rigged up on the roof of the Thames-side cottage enabled him to study, at all times of day, the sky, river and movement of boats, as a substitute for travel. The decline of his last years was one of physical rather than mental powers. To Francis Turner Palgrave he seemed in the last year of his life, 1851, 'as firm in tone of mind, as keen in interest, as when I had seen him years before'.

It was proof of his generous disposition towards artists that he left

some £140,000 to form a charity for old and distressed members of the profession, though the will became the subject of a Chancery court case that dragged on for years and thwarted his intentions in every respect. What was left of the money went to distant relatives. The paintings and drawings he wished to be housed in a specially built 'Turner Gallery' were never so accommodated. Many remarkable things were long hidden away in the bequest of some 300 paintings and over 19,000 drawings. Comparatively recent is the amends that now gives a rounded view of his achievement at the Tate Gallery in the series of rooms that show both works publicly exhibited and those he kept to himself, including examples of the watercolours from the main depository in the Print Room of the British Museum.

In his own time, Turner was acknowledged to be a great painter but usually as one beyond understanding, especially in his later works. A devotee of classical landscape, the celebrated patron and amateur, Sir George Beaumont, regarded him with positive enmity as one who broke all the classical rules. Hazlitt in 1816 had no hesitation in pronouncing Turner 'the ablest landscape painter now living', though criticizing his pictures as being 'too much abstractions of aerial perspective and rep resentations not properly of the objects of nature as of the medium through which they were seen'. Hazlitt intelligently appraised him as a 'painter of the elements', though unable to see that this was an exceptional virtue. Thackeray in the role of art critic regarded Turner as 'vibrating between the absurd and the sublime'. A cruder comment of the time described the marvellous *Snowstorm* as 'soap suds and whitewash'. Even John Constable, though admiring, seems to hint an adverse opinion when he opined that Turner's Royal Academy paintings of 1836 looked as if painted with 'tinted steam'. John Ruskin, who rallied to the defence (somewhat to Turner's alarm) in *Modern Painters,* was the only one to appreciate his real stature, though making 'truth to nature' the basis of his eulogy involved the critic in various confusions. Turner was 'true to nature' only to a point and in the sense that he studied—for instance — the different types of cloud, instead of confining himself to the conventional cumulus of the Old Masters; and could convey the real force of the sea instead of painting what Ruskin described as 'waves *en papillote* and peruke-like puffs of farinaceous foam', like his Dutch precursors in marine art. Yet the critic himself had to point out that the trees of *The Bay of Baiae* were not like any trees to be found in nature, but an idealized combination of stone pine and wych-elm!

Turner was intensely imaginative after a fashion that links him with the leaders of the Romantic movement in France. The *Fire at Sea* is close in spirit to Gericault's *Raft of the 'Medusa'*. The 'persistent melancholy' that Baudelaire found in Delacroix is like that of the author of the *Fallacies of Hope;* they were akin in the fascination that violence and tragedy had for them. This is one of the several characteristics that separate his art

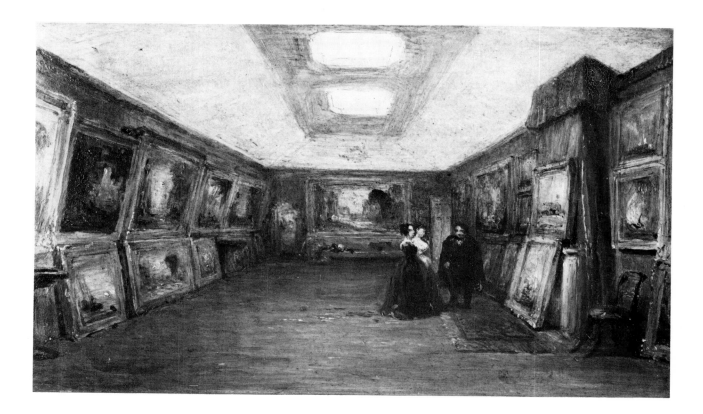

from that of the Impressionists. Impressionism required a settled condition of weather and a peaceful landscape with no out of the way features — not tempests, raging seas, and Alpine heights.

Claude Monet was certainly antipathetic to the Turner of the 'history' paintings. Camille Pissarro, with more admiration, was careful to point out that Turner had not attempted that analysis of colour in shadow that was so important a feature in the Impressionist evolution. Constable was certainly much nearer in temperament and style to the realistic generation of mid nineteenth-century France, besides having an immediate influence on Paris during his lifetime. The genius of Turner needs to be appraised on more comprehensive grounds. The rich and complex development makes a single label impossible. From the topographical picturesque to the reinterpretations of Claude and Poussin, the visions of Carthage, Rome and Venice, the romantic heights and distances, he ascends in a crescendo of mastery into the abstract realm of space, light, colour and movement — so much a preoccupation of the present time. It is clear now that Turner's greatness can no longer be questioned and that he takes an undisputed place among the world's giants of painting.

Fig. 14 **George Jones,
(1786–1869):** Lady
Visitors in Turner's Gallery

OIL ON MILLBOARD, 14.5 x 22.5 CM. C. 1852.
OXFORD, ASHMOLEAN MUSEUM

25

Outline Biography

1775 Born in London, 23 April, son of William Turner, hairdresser, and his wife Mary.

1787-90 Formative years. Makes copies of topographical watercolours. Lessons from Thomas Malton about 1790. Studies at Royal Academy Schools (1789-93). First exhibit at Royal Academy, 1790.

1791-8 Frequent sketching tours through England and Wales. First oil painting exhibited at Royal Academy, 1796.

1799 Elected Associate of the Royal Academy. Receives commissions for topographical watercolours.

1801 First visit to Scotland.

1802 First visit abroad. Journeys through France and Switzerland and studies at Louvre on way back. Elected full member of Royal Academy.

1805 Visits H.M.S. *Victory* on the Medway, talks with crew and hears accounts of Nelson's death for his painting of the Battle of Trafalgar. His mother dies about this time.

1807 Paints from nature on the Thames. First volume of *Liber Studiorum* issued. Elected Professor of Perspective at the Royal Academy.

1810 First of many visits to his patron and friend Walter Fawkes of Farnley Hall, Yorkshire.

1817 First visit to the Netherlands and Rhine Valley.

1819 First visit to Italy by way of Mont Cenis, Turin and Como to Milan, Verona, Venice, Bologna, Rome and Naples.

1821-8 Constant visits abroad: Paris and Normandy, 1821; Netherlands, 1825; Meuse, Moselle, Brittany and the Loire, 1826; and second visit to Rome, 1828. Intervals at home spent with Lord Egremont at Petworth and with John Nash on the Isle of Wight.

1829 Death of Turner's father.

1831 Visits Scotland for material to illustrate Sir Walter Scott's *Poems*. Stays at Abbotsford.

1834 Sketches burning of Houses of Parliament. Begins final phase of foreign travel: Venice, 1835 and 1840; Switzerland, 1836, 1841, 1842, 1844; Normandy coast, 1845.

1839 About this time took cottage in Chelsea (118-19 Cheyne Row) as a secluded retreat.

1840 First meeting with his young admirer, John Ruskin.

1843 First volume of *Modern Painters* published with sustained eulogy of Turner.

1850 Exhibited paintings for the last time.

1851 Dies in Chelsea 19 December. Buried at St. Paul's, 30 December.

Fig. 15 **S.W. Parrott (1813–69):** Turner on Varnishing Day

OIL ON PANEL, 25 x 23 CM. C. 1846 UNIVERSITY OF READING, GUILD OF ST GEORGE, RUSKIN COLLECTION

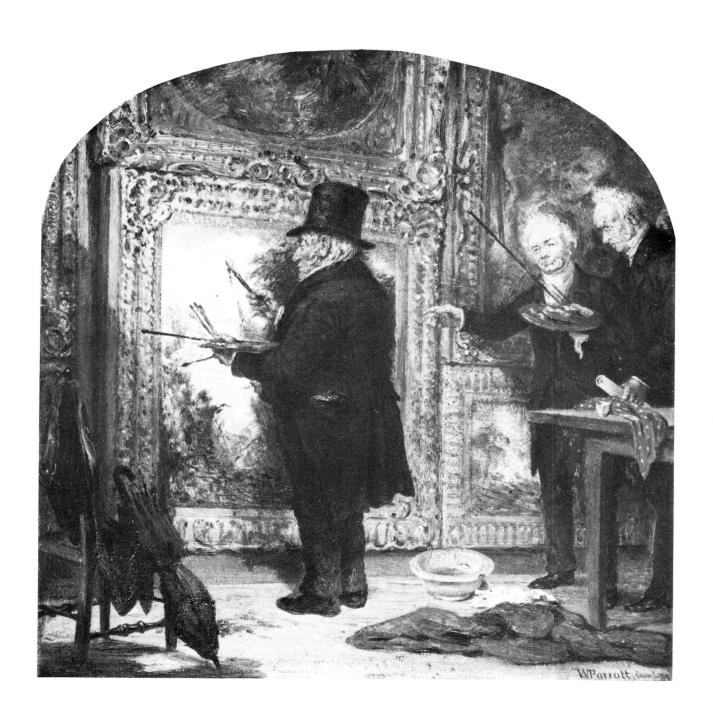

27

Select Bibliography

John Ruskin, *Modern Painters,* 5 vols, London 1843-60; reprinted in the *Library Edition* of *The Works of Ruskin,* ed. E.T. Cook and A. Wedderburn, 39 vols, London 1903-12 (vols III-VII). Extracts from *Modern Painters* can be found in *Ruskin Today,* ed. Sir Kenneth Clark, London 1964.

Walter Thornbury, *The Life of J.M.W. Turner R.A.,* 2 vols, London 1862; 2nd ed. in one volume, 1876, reprinted 1970.

A.J. Finberg, *Complete Inventory of the Drawings of the Turner Bequest,* 2 vols, London 1909.

———, *The Life of J.M.W. Turner,* R.A., Oxford 1939; 2nd ed. 1961.

John Rothenstein and Martin Butlin, *Turner,* London 1964.

Jack Lindsay, *J.M.W. Turner, His Life and Work,* London 1966.

——— (ed.), *The Sunset Ship, The Poems of J.M.W. Turner,* Lowestoft 1966.

Luke Herrmann, *Ruskin and Turner,* London 1968.

John Gage, *Colour in Turner,* London 1969.

Graham Reynolds, *Turner,* London 1969.

Gerald Wilkinson, *Turner's Early Sketchbooks, 1789-1802,* London 1972.

John Gage, *Turner: Rain, Steam and Speed,* London 1972.

Gerald Wilkinson, *The Sketches of Turner, R.A. 1802-20: genius of the Romantic,* London 1974.

———, *Turner's colour sketches: 1820-34,* London 1975.

Luke Herrmann, *Turner: Paintings, Watercolours, Prints and Drawings,* London 1975.

John Russell and Andrew Wilton, *Turner in Switzerland,* ed. W. Amstutz, Zurich 1976.

Martin Butlin and Evelyn Joll, *The Paintings of J.M.W. Turner,* 2 vols, New Haven and London 1977. The definitive *catalogue raisonne* of all known paintings in oil by Turner, including extensive quotations from contemporary newspaper reviews; each work is illustrated.

Andrew Wilton, *The Life and Work of J.M.W. Turner,* London 1979. This includes a condensed catalogue of the oil paintings, taken from Butlin and Joll (see above), a catalogue of more than fifteen hundred watercolours and a very full bibliography.

Eric Shanes, *Turner's Picturesque Views in England and Wales 1825-1838,* London 1979.

John Gage (ed.), *Collected Correspondence of J.M.W. Turner with an Early Diary and a Memoir by George Jones,* Oxford 1980.

EXHIBITION CATALOGUES

Turner: Imagination and Reality. Catalogue of an exhibition held at the Museum of Modern Art, New York, 1966, with a stimulating essay by Lawrence Gowing.

Turner 1775-1851. Catalogue of the bicentenary exhibition organized by the Tate Gallery and The Royal Academy of Arts, 1974-75 (now out of print).

Turner in the British Museum, Drawings and Watercolours. Catalogue of an exhibition held in the Department of Prints and Drawings, 1975-76.

List of Illustrations

Colour Plates

1. Moonlight, A Study at Millbank
 OIL ON PANEL. EXHIBITED 1797. LONDON, TATE GALLERY

2. Buttermere Lake, with Part of Cromackwater Cumberland, a Shower
 CANVAS. EXHIBITED 1798. LONDON, TATE GALLERY

3. South View of Christ Church, etc., from the Meadows
 WATERCOLOUR, WITH SOME PEN AND BLACK INK, OVER PENCIL. 1798-9. OXFORD, ASHMOLEAN MUSEUM

4. Calais Pier, with French Poissards (sic) Preparing for Sea: an English Packet Arriving
 CANVAS. EXHIBITED 1803. LONDON, NATIONAL GALLERY

5. The Thames near Walton Bridges
 OIL ON VENEER. C.1807. LONDON, TATE GALLERY

6. Tree Tops and Sky, Guildford Castle (?), Evening
 OIL ON VENEER. C.1807. LONDON, TATE GALLERY

7. The Fall of an Avalanche in the Grisons
 CANVAS. EXHIBITED, 1810. LONDON, TATE GALLERY

8. The Wreck of a Transport Ship
 CANVAS. C.1810. LISBON, THE CALOUSTE GULBENKIAN FOUNDATION

9. Snow Storm: Hannibal and his Army Crossing the Alps
 CANVAS. EXHIBITED 1812. LONDON, TATE GALLERY

10. Frosty Morning
 CANVAS. EXHIBITED 1813. LONDON, TATE GALLERY

11. Dido Building Carthage; or the Rise of the Carthaginian Empire
 CANVAS. EXHIBITED 1815. LONDON, NATIONAL GALLERY

12. Crossing the Brook
 CANVAS. EXHIBITED 1815. LONDON, TATE GALLERY

13. Dort, or Dordrecht, the Dort Packet-Boat from Rotterdam Becalmed
 CANVAS. EXHIBITED 1818. NEW HAVEN, CONNECTICUT, YALE CENTER FOR BRITISH ART (PAUL MELLON COLLECTION)

14. Venice, Looking East from the Giudecca: Sunrise
 WATERCOLOUR. 1819. LONDON, BRITISH MUSEUM

15. Venice, San Giorgio from the Dogana: Sunrise
 WATERCOLOUR. 1819. LONDON, BRITISH MUSEUM

16. The Bay of Baiae, with Apollo and the Sibyl
 CANVAS. EXHIBITED 1823. LONDON, TATE GALLERY

17. Detail from 'The Bay of Baiae, with Apollo and the Sibyl' (Plate 16)

18. Storm-clouds: Sunset
 WATERCOLOUR OVER PENCIL. C.1825. LONDON, BRITISH MUSEUM

19. Petworth Park: Tillington Church in the Distance
 CANVAS. C.1828. LONDON, TATE GALLERY

20. Interior at Petworth
 WATERCOLOUR AND BODY-COLOUR ON BLUE PAPER. C.1828. LONDON, BRITISH MUSEUM

21. Chichester Canal
 CANVAS. C.1828. LONDON, TATE GALLERY

22. The Chain Pier, Brighton
 CANVAS, C.1828. LONDON, TATE GALLERY

23. A Ship Aground
 CANVAS. C.1828. LONDON, TATE GALLERY

24. Playing Billiards, Petworth
 WATERCOLOUR AND BODY-COLOUR ON BLUE PAPER. C.1828. LONDON, BRITISH MUSEUM

25. Ariccia (?): Sunset
 CANVAS. 1828? LONDON, TATE GALLERY

26. Archway with Trees by the Sea
 CANVAS. 1828? LONDON, TATE GALLERY

27. Ulysses Deriding Polyphemus – Homer's Odyssey
 CANVAS. EXHIBITED 1829. LONDON, NATIONAL GALLERY

28. Detail from 'Ulysses Deriding Polyphemus – Homer's Odyssey' (Plate 27)

29. Death on a Pale Horse (?)
 CANVAS. C.1825-30. LONDON, TATE GALLERY

30. Scene on the Loire
 WATERCOLOUR AND BODY-COLOUR ON BLUE PAPER. 1826-30. OXFORD, ASHMOLEAN MUSEUM (RUSKIN SCHOOL COLLECTION)

31. Rocky Bay with Figures
 CANVAS. C.1830. LONDON, TATE GALLERY

32. The Evening Star
 CANVAS. C.1830. LONDON, NATIONAL GALLERY

33. Venice
 CANVAS. EXHIBITED 1834. WASHINGTON, D.C., NATIONAL GALLERY OF ART (WIDENER COLLECTION)

Text Figures

Comparative Figures

16. Fishermen at Sea
CANVAS. EXHIBITED 1796. LONDON, TATE GALLERY

17. Dunstanborough Castle, N.E. Coast of Northumberland. Sun-Rise after a Squally Night
CANVAS. EXHIBITED 1798. MELBOURNE, NATIONAL GALLERY OF VICTORIA

18. Interior of Ely Cathedral: Looking towards the North Transept and Chancel
WATERCOLOUR. 1796. ABERDEEN, CITY ART GALLERY

19. The Devil's Bridge, Pass of St Gothard
PENCIL, WATERCOLOUR AND BODYCOLOUR AND SCRAPING-OUT ON WHITE PAPER PREPARED WITH A GREY WASH. 1802 LONDON, BRITISH MUSEUM

20. Detail from 'The Thames near Walton Bridges'
OIL ON VENEER. C.1807. LONDON, TATE GALLERY

21. The Visit to the Tomb
CANVAS. EXHIBITED 1850. LONDON, TATE GALLERY

22. Dorchester Mead, Oxfordshire
CANVAS. EXHIBITED 1810. LONDON, TATE GALLERY

23. Rome: The Basilica of Constantine and the Colosseum
PENCIL, WATERCOLOUR AND BODY-COLOUR ON WHITE PAPER PREPARED WITH GREY WASH. 1819. LONDON, BRITISH MUSEUM

24. Venice, the Piazzetta with the Ceremony of the Doge Marrying the Sea
CANVAS. C.1835. LONDON, TATE GALLERY

25. Venice from the Canale della Giudecca, Chiesa di S. Maria della Salute etc.
CANVAS. EXHIBITED 1840. LONDON, VICTORIA AND ALBERT MUSEUM

26. Petworth, Sussex, the Seat of the Earl of Egremont: Dewy Morning
CANVAS. EXHIBITED 1810. PETWORTH HOUSE, H.M. TREASURY AND THE NATIONAL TRUST

27. Petworth: The Drawing Room
BODY-COLOUR ON BLUE PAPER. 1828? LONDON, BRITISH MUSEUM

28. Petworth: an Artist Painting in a Room with a Large Fanlight
BODY-COLOUR ON BLUE PAPER. 1828? LONDON, BRITISH MUSEUM

29. Coast Scene near Naples
OIL ON MILLBOARD. 1828? LONDON, TATE GALLERY

30. Chateau of Amboise
ENGRAVING ON STEEL BY J.B. ALLEN, AFTER TURNER. 1833. LONDON, BRITISH MUSEUM

31. Venice: the Grand Canal
WATERCOLOUR OVER SLIGHT PENCIL. OUTLINE, PEN AND RED AND BLUE INK AND SOME HEIGHTENING WITH WHITE. 1840. OXFORD, ASHMOLEAN MUSEUM

32. The Oxford Street Pantheon after the Fire of 14 January 1792
WATERCOLOUR OVER PENCIL. EXHIBITED 1792. LONDON, BRITISH MUSEUM

33. Detail from the 'The Burning of the Houses of Parliament'
WATERCOLOUR. 1834. LONDON, BRITISH MUSEUM

34. Petworth: A Group of Ladies Conversing
BODY-COLOUR ON BLUE PAPER. 1828? LONDON, BRITISH MUSEUM

35. Breakers on a Flat Beach
CANVAS. C.1830-5. LONDON, TATE GALLERY

36. The Battle of Trafalgar, as Seen from the Mizen Starboard Shrouds of the Victory
CANVAS. EXHIBITED 1806. LONDON, TATE GALLERY

37. Boccaccio Relating the Tale of the Birdcage
CANVAS. EXHIBITED 1828. LONDON, TATE GALLERY

38. A Country Blacksmith Disputing upon the Price of Iron, and the Price Charged to the Butcher for Shoeing his Poney
OIL ON PANEL. EXHIBITED 1807. LONDON, TATE GALLERY

Moonlight, A Study at Millbank

OIL ON PANEL, 31.5 x 40.5 CM. EXHIBITED 1797. LONDON, TATE
GALLERY

One of the smallest oil paintings ever exhibited by Turner
and the only exhibited work to be termed a study, this pic-
ture shows the artist working within the popular genre of
moonlit scenes. The most notable exponents of this style in
England were Joseph Wright (1734–97) and Philip James
de Loutherbourg (1740–1812) and Turner had explored
the studied effects of work such as theirs in his first ex-
hibited oil, *Fishermen at Sea*, of the previous year (Fig.16).
Apart from the obvious suggestion offered by its title and
the artist's choosing a well-known spot on the Thames for
his viewpoint, in its scale, with its thinly applied paint and
a looser composition, the Millbank study possesses an im-
mediacy altogether lacking in the 1796 *Moonlight* and more
akin to that which had hitherto existed in his sketchbooks.

Fig. 16 Fishermen at Sea

CANVAS, 91.5 x 122.5 CM. EXHIBITED 1796. LONDON, TATE GALLERY

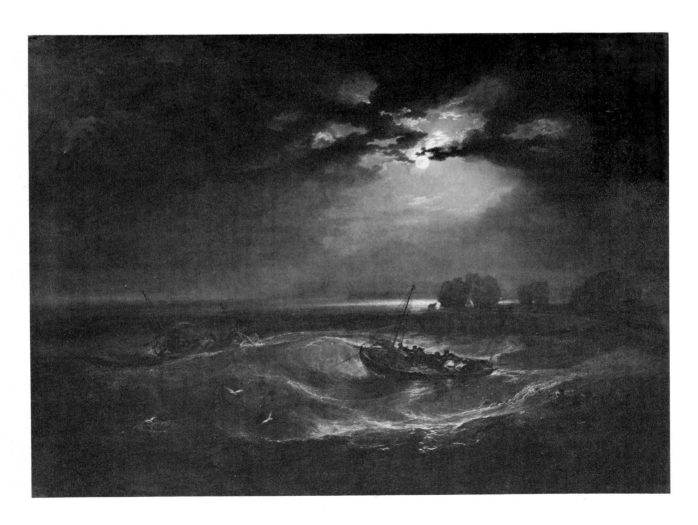

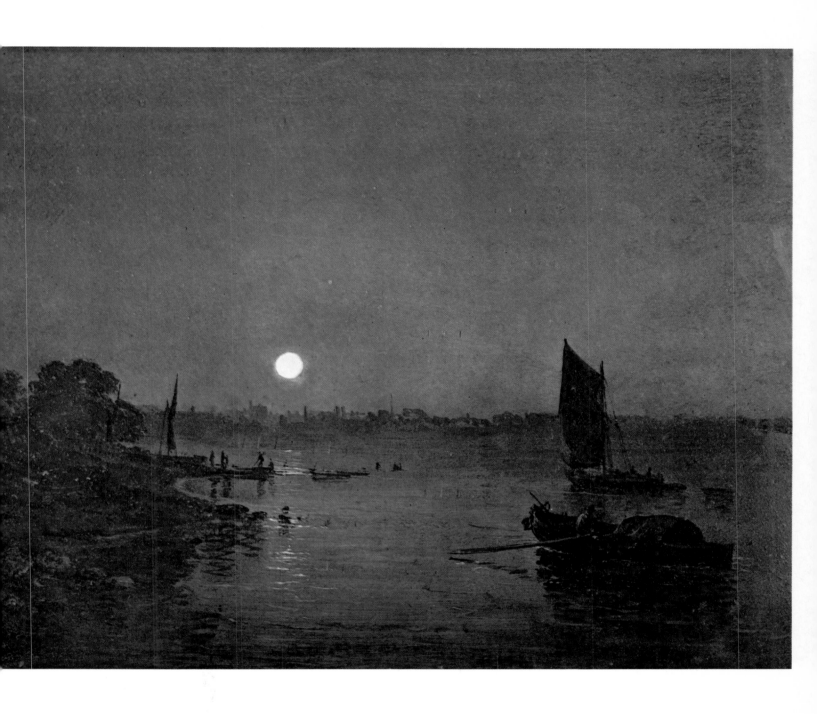

Buttermere Lake, with part of Cromackwater, Cumberland, a Shower

CANVAS, 91.5 x 122 CM. EXHIBITED 1798. LONDON, TATE GALLERY

Exhibited at the Royal Academy in 1798 with the following lines adapted from James Thomson's *The Seasons:*

> Till in the western sky the downward sun
> Looks out effulgent — the rapid radiance instan-
> taneous strikes
> Th'illumin'd mountains — in a yellow mist
> Bestriding earth — The grand ethereal bow
> Shoots up immense, and every hue unfolds.

The painting is based closely on a small pencil and water-colour sketch made during Turner's first trip to the Lake District in the summer of 1797. The trip, to an area noted for its scenery, and the quotation from Thomson — whose words also accompanied three other pictures by Turner in the same Academy exhibition — emphasize Turner's in-terest in the Picturesque; very possibly the artist was aware of the fact that Thomson's lines had been used by William Gilpin, the apostle of the Picturesque movement, in a description of Derwentwater made as early as 1772. The sombre colouring of the picture and its relationship to a conventional mode of looking at landscape were obviously in the mind of a fellow artist when, having seen this and another of Turner's 1798 exhibits, he described the painter as ' . . . a timid man afraid to venture'. For another exhibit of 1798 — but not the picture included in the last criticism — see Dunstanborough Castle (Fig.17).

Fig. 17 Dunstanborough Castle, N.E. Coast of Northumberland. Sun-Rise after a Squally Night

CANVAS, 92 x 123 CM. EXHIBITED 1798. MELBOURNE, NATIONAL GALLERY OF VICTORIA (PRESENTED BY THE DUKE OF WESTMINSTER)

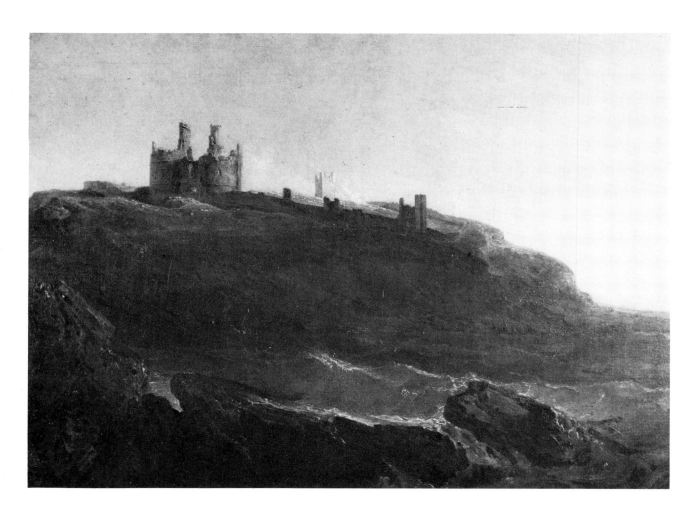

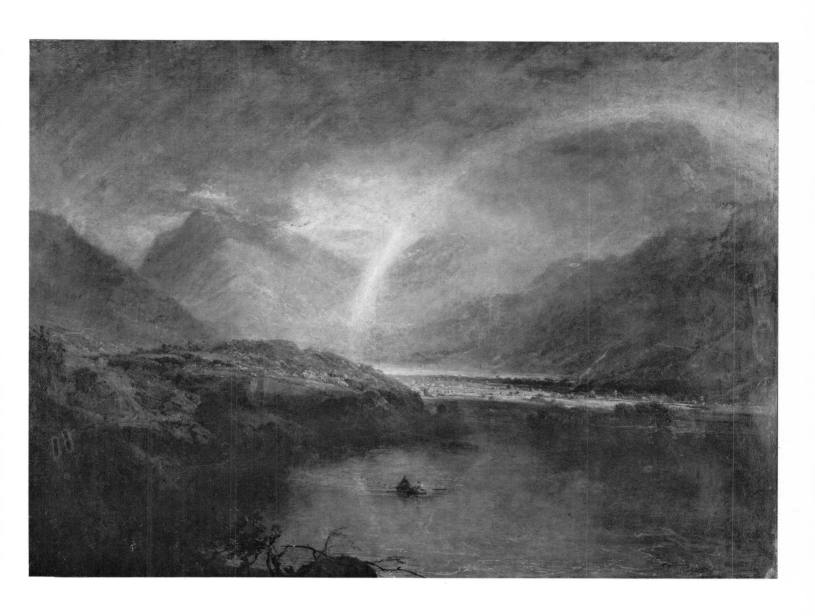

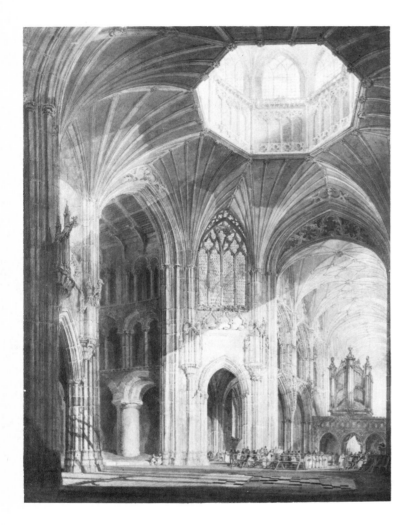

South View of Christ Church, etc., from the Meadows

WATERCOLOUR, WITH SOME PEN AND BLACK INK, OVER PENCIL, 31.5 x 45 CM. 1798–9. OXFORD, ASHMOLEAN MUSEUM

Turner's first exhibited pictures were topographical watercolours — a development that arose out of his work in the studio of Thomas Malton, the architectural topographer, during 1789 and, later, his contact with the work of Edward Dayes and Thomas Hearne. The popularity of picturesque views of England and the milieu in which Turner worked during his formative years undoubtedly stimulated him to make, in 1791, the first of his trips around the country in search of material — a habit he was to continue for the rest of his career. The *South View of Christ Church* was produced at a time when Turner was clearly setting out to establish his reputation as a painter in the more prestigious medium of oil as, for example, in *Buttermere Lake* (Plate 2). The subject recalls both an earlier, cruder rendering of *Christ Church from Merton Fields* made in 1791 and now in the British Museum, and a finished view of *c.* 1794, also from the south, of the buildings at the foot of Tom Tower. For the 1798 work the artist seems to have referred to a pencil study made *c.* 1794. The watercolour was one of two commissioned by the Clarendon Press, with a fee of twenty-one guineas, for the Oxford Almanack; the commission recognized the status Turner by now had, at the age of twenty four, as one of the outstanding topographical draughtsmen of his day (see Fig.18).

Fig. 18 Interior of Ely Cathedral: Looking towards the North Transept and Chancel

WATERCOLOUR, 63 x 49 CM. 1796. ABERDEEN, CITY ART GALLERY

Calais Pier, with French Poissards *(sic)* Preparing for Sea: an English Packet Arriving

CANVAS, 170 x 240 CM. EXHIBITED 1803. LONDON, NATIONAL GALLERY

Besides demonstrating the artist's continued preoccupation with seascapes, first shown in the *Fishermen at Sea* (Fig.16) and continued most notably in his large marine subjects exhibited at the Royal Academy in 1801 and 1802, *Calais Pier* reflects one facet of Turner's experiences during his first trip abroad to France and Switzerland between July and October 1802. Autobiographical to a certain extent — Turner had noted 'Nearly swampt' in his sketchbook when describing his own landing at Calais — this painting offers for the first time evidence of the artist's considered response to his confrontion with the terrifying, or sublime, aspects of nature. This response was to be orchestrated most forcefully in his later works — specifically in *Snow Storm: Steam-Boat off a Harbour's Mouth,* exhibited in 1842 (Plate 45). The incident depicted was perhaps a fitting prelude to Turner's travels in the Swiss Alps when he was to record, in dramatic, vigorous, sketches such as *The Devil's Bridge, Pass of St Gothard* (Fig.19), the yet more sublime.

Fig. 19 The Devil's Bridge, Pass of St Gothard

PENCIL, WATERCOLOUR AND BODYCOLOUR AND SCRAPING-OUT ON WHITE
PAPER PREPARED WITH A GREY WASH, 47 x 31 CM. 1802. LONDON, BRITISH
MUSEUM

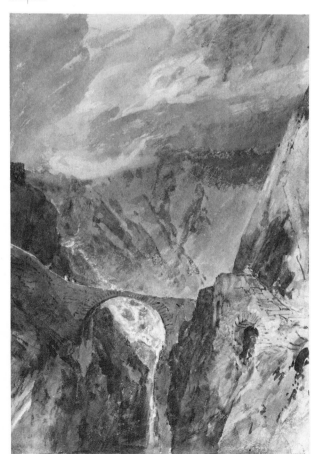

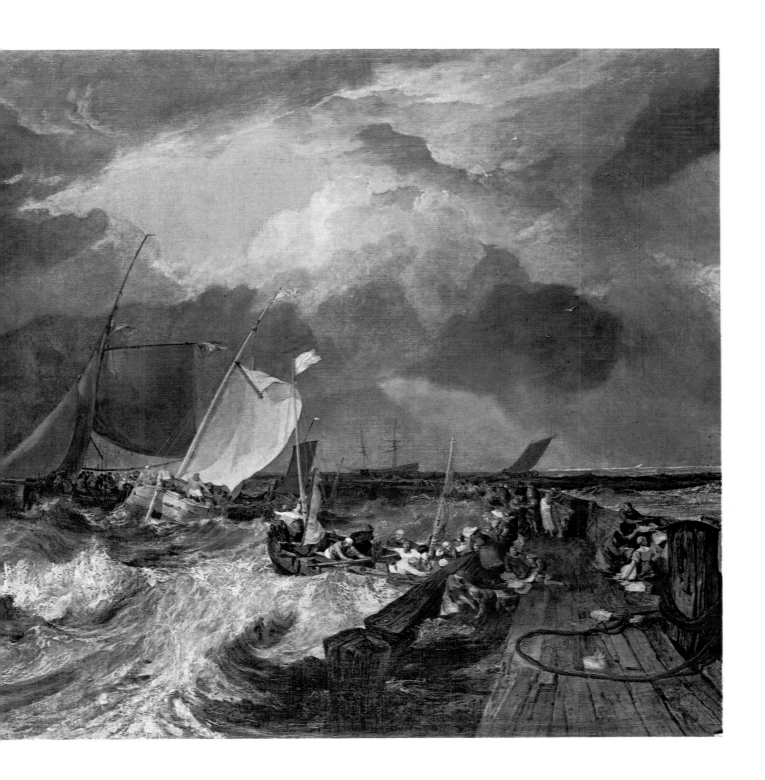

The Thames near Walton Bridges

OIL ON VENEER, 37 x 73.4 CM. C. 1807. LONDON, TATE GALLERY

The Thames near Walton Bridges is one in a series of eighteen small oil sketches on mahogany veneer, all of about the same date and the subjects of which are all located in the upper reaches of the Thames. From their size and the rapid handling of the paint, as shown in Figure 20, it is most likely that they were painted out-of-doors and the presence, in most instances, of the river in the foreground, as here, suggests that the views were taken from a boat.

Fig. 20 Detail from 'The Thames near Walton Bridges'

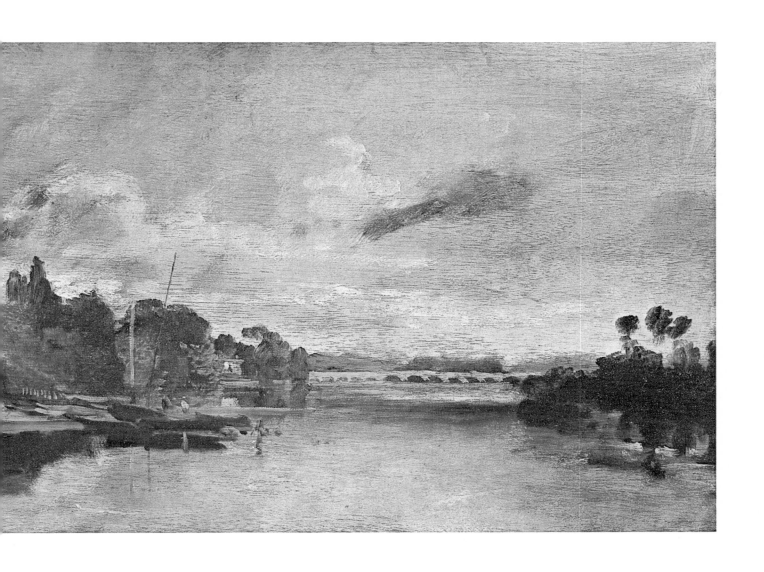

6

Tree Tops and Sky, Guildford Castle (?), Evening

OIL ON VENEER, 27.5 x 73.5 CM. C.1807. LONDON, TATE GALLERY

Turner's Thames oil sketches of c. 1807 – which include *Tree Tops and Sky* as well as *The Thames near Walton Bridges* (Plate 5) – form, together with a number of Thameside watercolours of the same period, perhaps the most significant group of plein-air work in the artist's entire output. His out-door sketching was usually restricted to hurried notes, in sketchbooks, to be finished later; but here there seems on Turner's part a very deliberate attempt to study landscape and sky in a way which he had not yet fully explored. The work was probably partly a result of Turner acquiring a *pied a terre* on the river at Isleworth in 1804 or 1805 and the sense of place and the spirit that permeates these paintings inevitably invites comparisons with John Constable's oil sketches of Dedham Vale produced a few years later.

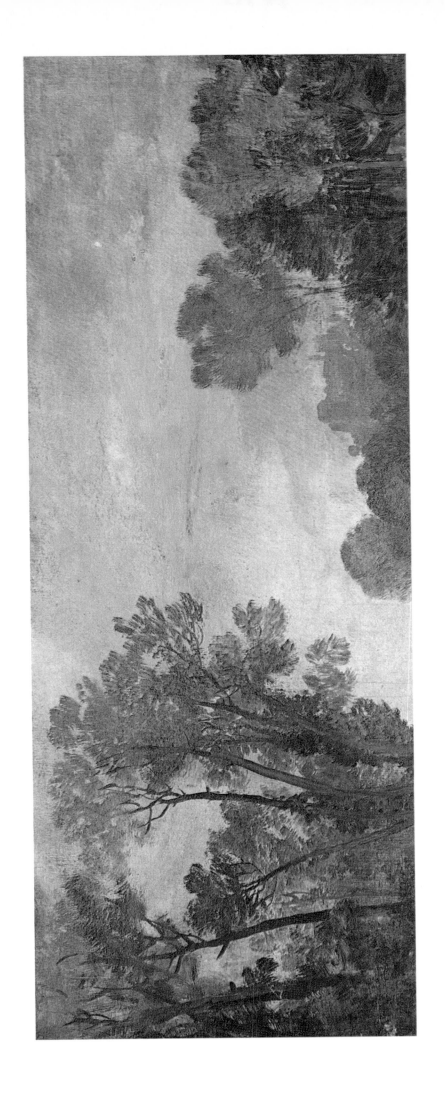

The Fall of an Avalanche in the Grisons

CANVAS, 90 x 120 CM. EXHIBITED 1810. LONDON, TATE GALLERY

Exhibited, in 1810, at Turner's Gallery in Queen Anne Street, with the following lines:

> The downward sun a parting sadness gleams,
> Portenteous lurid thro' the gathering storm;
> Thick drifting snow on snow,
> Till the vast weight bursts thro' the rocky barrier;
> Down at once, its pine clad forests,
> And towering glaciers fall, the work of ages
> Crashing through all! extinction follows,
> And the toil, the hope of man – o'erwhelms.

There is no evidence of Turner having visited the canton of the Grisons during his Swiss journey of 1802. It seems, rather, that at least some of the inspiration for this picture came from his reading of Thomson's *The Seasons* where, in *Winter*, there is a description, in similar terms to Turner's verse, of an avalanche of snow in the Grisons; additionally, he was also familiar with two paintings of avalanches by de Loutherbourg, one of which is now in the Tate Gallery. Turner clearly drew upon his memories of Alpine scenery; at the same time he heightens the impact of Thomson's and de Loutherbourg's images – both of which contain people – by depopulating the scene and making the instrument of destruction a jagged boulder sharply silhouetted against the snow, at the centre of carefully composed diagonals.

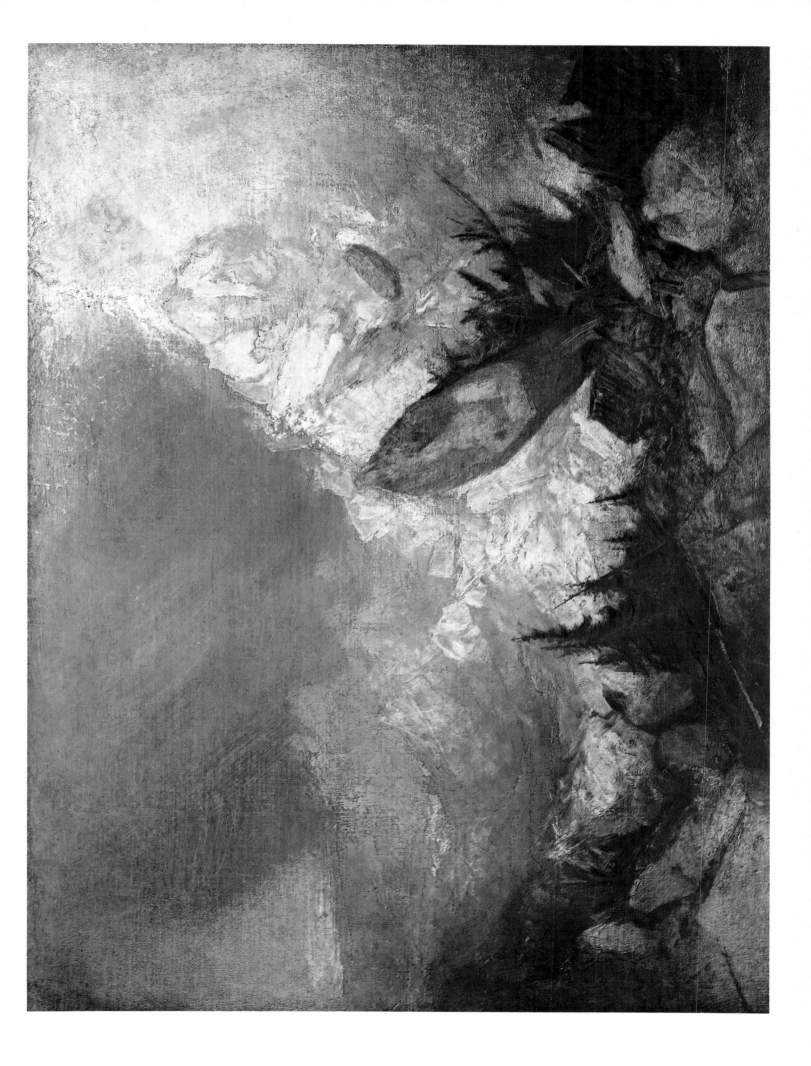

8

The Wreck of a Transport Ship

CANVAS, 173 x 241 CM. C.1810. LISBON, CALOUSTE GULBENKIAN FOUNDATION

It is not known if the wreck shown is of any particular ship but the narrative strength of the picture does relate it to a tradition of wreck paintings, based on actual incidents, which had been shown by other English artists at the Royal Academy from the late eighteenth century onwards. Turner here develops the well-tried compositional devices associated with such works, and also with earlier Dutch models – the dramatic, fragile diagonals of masts and oars juxtaposed to the leaden swirl of waves and clouds – into a powerful vortex which itself forms a diagonal across the canvas. Unlike an earlier shipwreck exhibited by Turner in 1805 the composition here is dominated by the wreck looming at the edge of the picture. Such dramatic asymetry can be seen in *The Fall of an Avalanche in the Grisons* (Plate 7) and seems to suggest that the power of Alpine scenery, noted during his journey of 1802, may have influenced the manner in which Turner dramatized the power of natural forces over the frailty of man; the most consummate example of such a dramatization at this period is seen in the *Hannibal* of two years later (Plate 9).

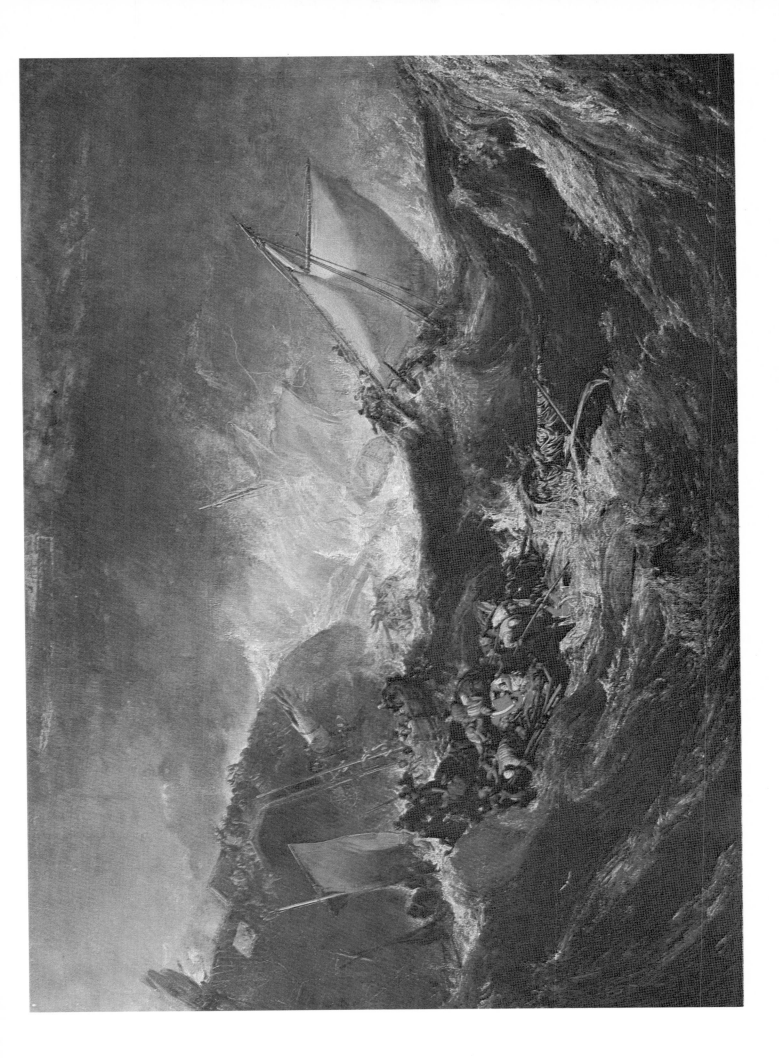

9

Snow Storm: Hannibal and his Army Crossing the Alps

CANVAS, 146 x 237.5 CM. EXHIBITED 1812. LONDON, TATE GALLERY

Though Turner had exhibited subjects from classical history before, *Snow Storm: Hannibal and his Army Crossing the Alps* has a special significance for a number of reasons. For the first time a lengthy quotation from the artist's own manuscript poem 'The Fallacies of Hope' appeared in the Academy catalogue; the subject matter, for which prevailing academic conventions would normally have demanded a more explicit use of figures, relies for its force almost entirely upon atmospheric effect; allusion to historical fact is relegated to rape and pillage at the lower edge of the canvas and the silhouetted elephants in the distance; and with its concentrated vortex of light and dark with the sun at its centre, the composition is the most daring yet attempted by Turner. In this last respect the painting is a direct descendant of *The Wreck of a Transport Ship* of *c.* 1810 (Plate 8). In its colouring and in the manner in which the paint is applied to the canvas the work looks forward to what Turner himself called his 'indistinctness' – a word he applied to *Staffa, Fingal's Cave*, exhibited in 1832 (Fig. 11) – and what John Constable termed in 1836 'tinted steam, so evanescent, and so airy'.

The subject of Hannibal had been in Turner's mind for some years before he produced the picture and he must undoubtedly have been aware of Napoleon's famous crossing of the Alps, with thirty thousand men, in 1800.

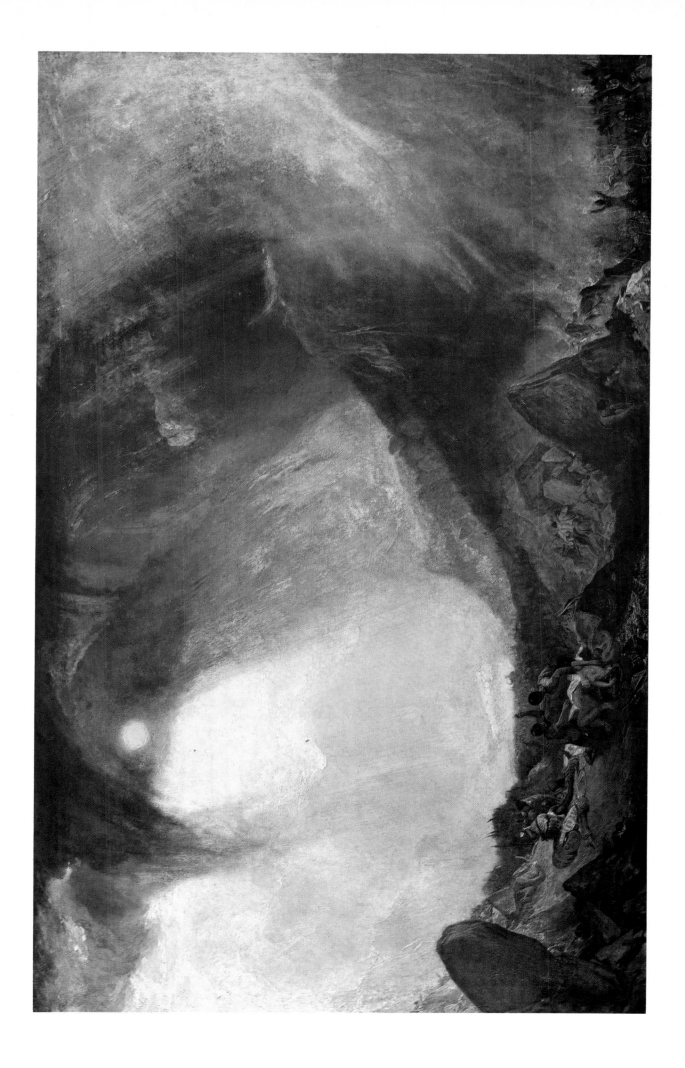

Frosty Morning

CANVAS, 113.5 x 174.5 CM. EXHIBITED 1813. LONDON, TATE GALLERY

Described by the son of one of Turner's oldest friends as among the artist's favourite pictures, *Frosty Morning* was apparently based upon a sketch made while he was journeying in Yorkshire – the stage coach in which Turner was travelling being shown approaching the spectator along the road to the left. The simplicity of the composition, the coolness of the colouring, the directness of the observation, match exactly the single line from Thomson's *Autumn*, which was printed beneath the title of the painting in the Royal Academy catalogue: 'The rigid hoar frost melts before his beam.' It is a conjunction of painting and poetry with a purity that is rarely equalled in any other picture by Turner; Constable's close friend, Archdeacon Fisher, called it 'a picture of pictures'.

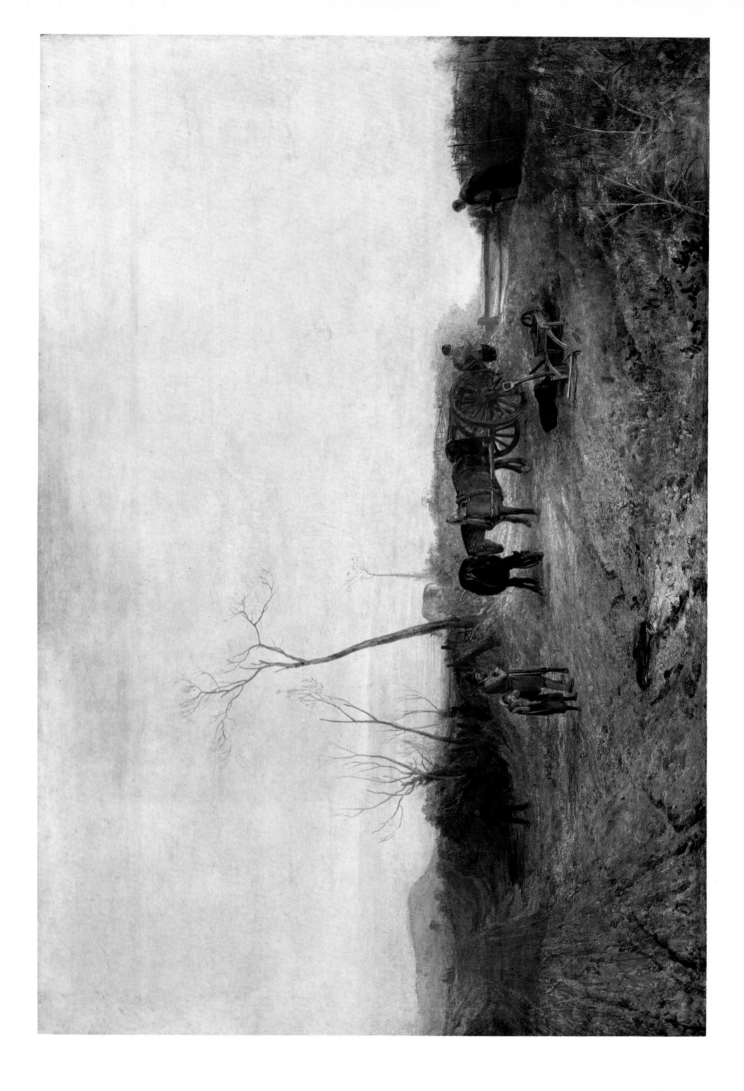

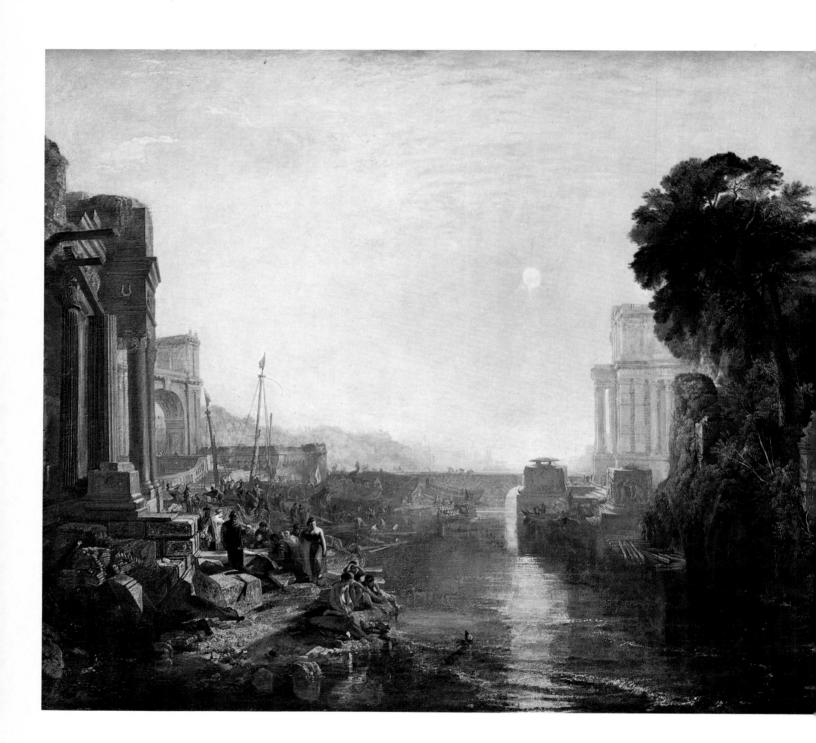

Dido Building Carthage; or the Rise of the Carthaginian Empire

CANVAS, 155.5 x 232 CM. EXHIBITED 1815. LONDON, NATIONAL GALLERY

The subject, taken from the First Book of Virgil's *Aeneid,* depicts Dido building the citadel of Byrsa – subsequently the centre of Carthage – following her flight from Tyre after her husband Sichaeus had been murdered by Pygmalion. The tomb on the right bears the inscription 'Sichaeo' and the manner of his death is alluded to in the frieze which runs along its base.

The debt Turner owed, in this work, to the landscapes of Claude Lorraine was remarked upon at the time the painting was first shown. It would perhaps be true to say that no more striking example of an artist's debt to the Old Masters had appeared on the walls of the Academy since its foundation in 1768. Sir Joshua Reynolds had urged his students to look at the great masters and 'consider them as models which you are to imitate, and at the same time as rivals with which you are to contend'; Turner, undoubtedly conscious of these words, for he was a great admirer of Reynolds, and aware also of his own place in English and European art, bequeathed this painting, and one other, to the National Gallery where it now hangs at the artist's request next to Claude's *Seaport: The Embarkation of the Queen of Sheba.*

A companion picture, *The Decline of the Carthaginian Empire* was exhibited by Turner in 1817 and he was to return again to the subject of the *Dido* in one of his final paintings, *The Visit to the Tomb* of 1850 (see Fig. 21).

Fig. 21 The Visit to the Tomb

CANVAS, 91.5 x 122 CM. EXHIBITED 1850. LONDON, TATE GALLERY

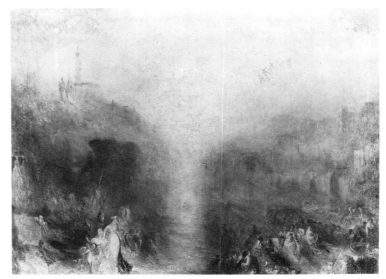

Crossing the Brook

CANVAS, 193 x 165 CM. EXHIBITED 1815. LONDON, TATE GALLERY

The essentially Italianate nature of this landscape, with its warm colouring and the atmosphere permeated by the light of the sun, obscures the fact that it is a view of the River Tamar with Calstock Bridge in the middle distance. The picture is a product of Turner's visit to Devonshire in the summer of 1813, but, as with *Dido Building Carthage* (Plate 11), the debt to Claude is clear – especially if a comparison is made with Claude's *Landscape: Hagar and the Angel,* in the National Gallery. Turner would have known this picture but *Crossing the Brook* also recalls, particularly, the literary roots on which he had chosen to base four oil paintings of 1798 (see *Buttermere Lake,* Plate 2). The ideal Claudian landscape, couched in terms of English scenery, which Turner knew from Thomson's *The Seasons,* here in *Crossing the Brook* stands on its own, with allusions as rich as those which were to inform the artist's later Italian landscape – as, for example, in *The Bay of Baiae* (Plate 16).

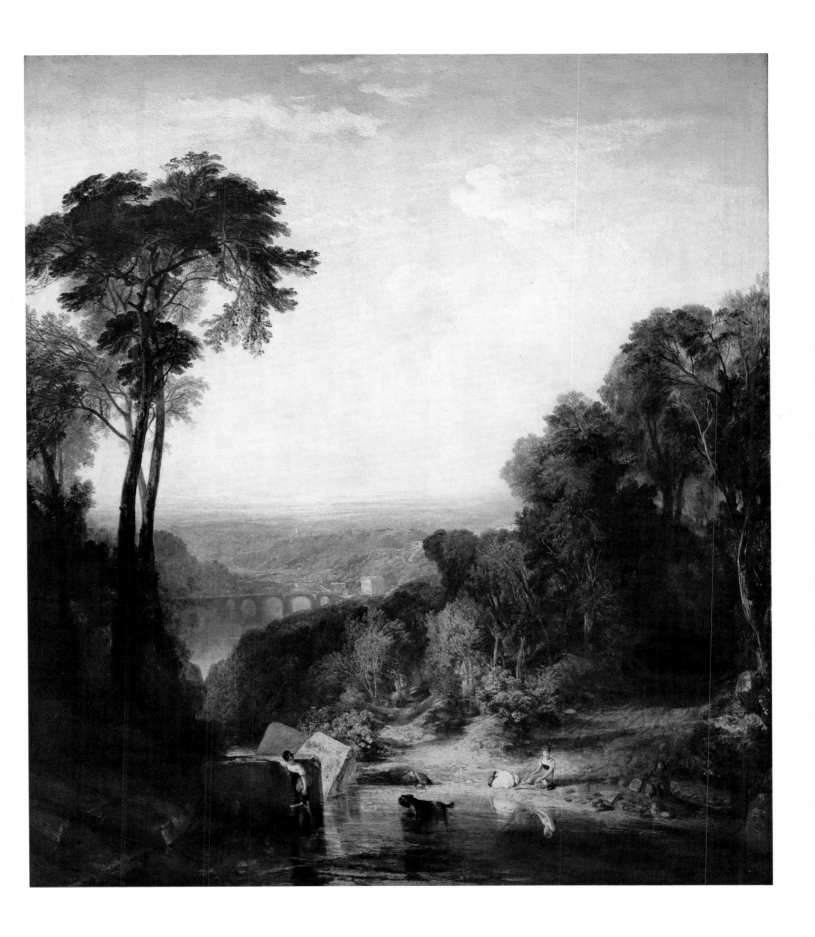

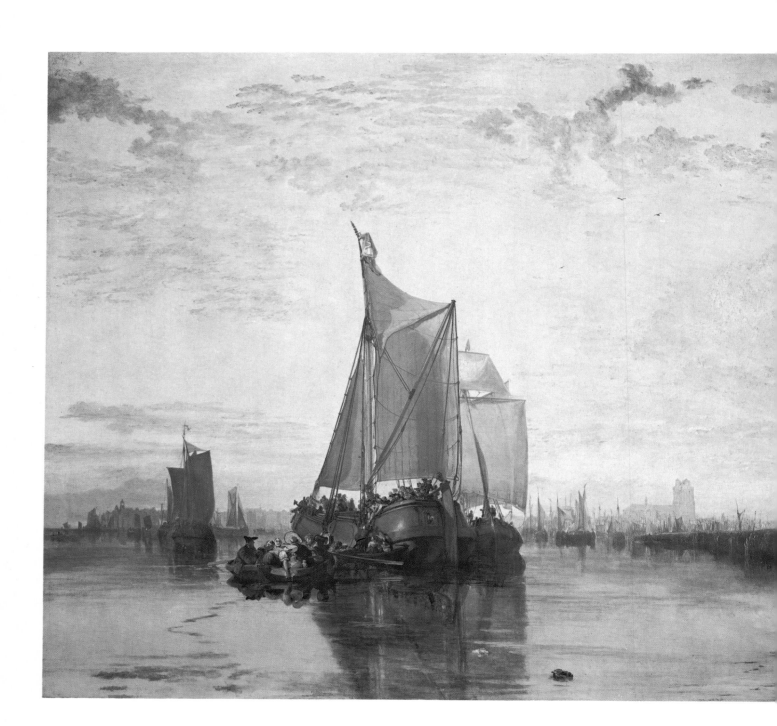

Dort, or Dordrecht, the Dort Packet-Boat from Rotterdam Becalmed

CANVAS, 157.5 x 233 CM. EXHIBITED 1818. NEW HAVEN, CONNECTICUT, YALE CENTER FOR BRITISH ART (PAUL MELLON COLLECTION)

During August and September 1817 Turner made his first visit to Belgium, the Rhine and Holland, visiting Dordrecht on his way back to England via Rotterdam. A number of a small drawings in sketchbooks used during the trip relate to the finished painting but, as with *Crossing the Brook* (Plate 12), the *Dort* has as its principal influence the work of an Old Master; likewise, it represents the culmination of one aspect of Turner's prolonged study of these painters. In this case it was Aelbert Cuyp, a Dutch artist whose landscapes, painted in the vicinity of Dordrecht and often including that same tower of the Grote Kerk which features in Turner's picture, were well represented in English collections. In his handling of light and aerial perspective Cuyp was ranked by some writers alongside Claude, and for Turner especially he 'to a judgement so truly qualified knew where to blend minutiate in all the golden colour of ambient vapour'. This statement was made in 1811 and even earlier, in Thameside scenes such as *Dorchester Mead, Oxfordshire* of 1810 (Fig. 22) the artist had shown his awareness of Cuyp's work. Both the *Dort* and *Crossing the Brook* are strikingly similar conclusions in that process of fusing personal experience with a knowledge of the Old Masters which is central to Turner's art. Very highly regarded at the time of its exhibition the picture was bought for five hundred guineas by the artist's patron, Walter Fawkes.

Fig. 22 Dorchester Mead, Oxfordshire

CANVAS, 101.5 x 130 CM. EXHIBITED 1810. LONDON, TATE GALLERY

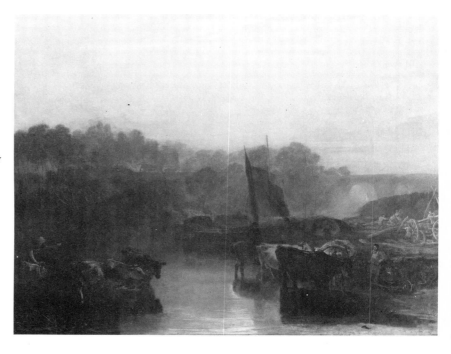

Venice, Looking East from the Giudecca: Sunrise

WATERCOLOUR, 22 x 28 CM. 1819 LONDON, BRITISH MUSEUM

Turner stayed in Venice on his way to Rome in September 1819. During his four months in Italy he was to fill nineteen small sketchbooks with numerous pencil studies of the sights that he saw; each book has its contents described on a label on its cover. The detail and method which Turner adopted in his work indicate both how important he considered his Italian tour to be and how much he regarded it as providing material for future reference. Four larger sketchbooks contained sheets with a grey wash on one side and Turner labelled three of these volumes C (for 'Colour') *Studies:* the view of the Basilica of Constantine (Fig. 23) is from one of these. Thirteen watercolour studies are to be found in the *Como and Venice* sketchbook, including four Venetian subjects – one of which is shown here.

Fig. 23 Rome: The Basilica of Constantine and the Colosseum

PENCIL, WATERCOLOUR AND BODY-COLOUR ON WHITE PAPER PREPARED WITH GREY WASH, 23 x 37 CM. 1819. LONDON, BRITISH MUSEUM

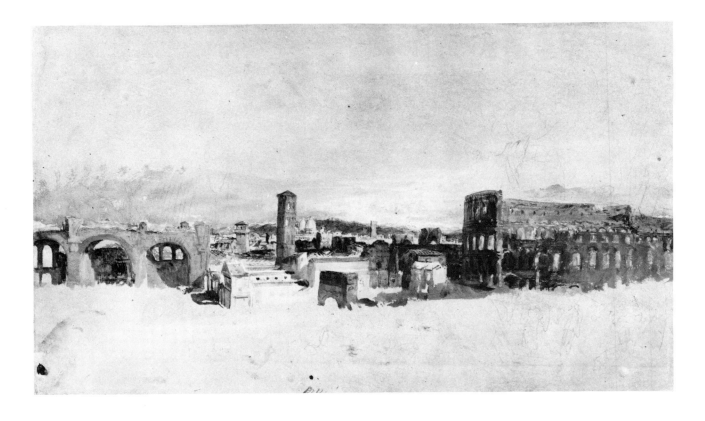

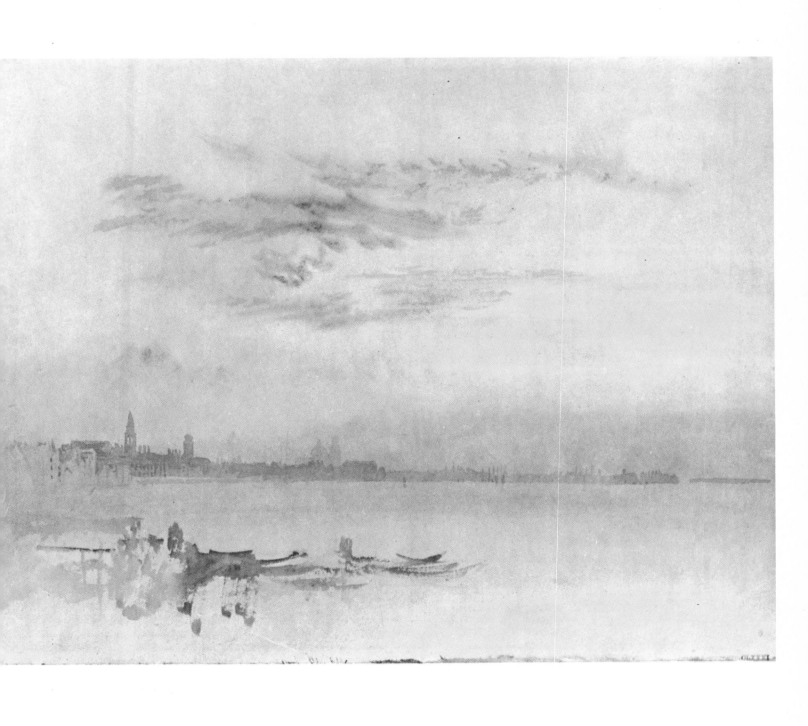

15

Venice, San Giorgio from the Dogana: Sunrise

WATERCOLOUR, 22 x 28 CM. 1819 LONDON, BRITISH MUSEUM

The two pictures illustrated here and in Plate 14, together with two other views of the Zitelle and the Dogana and the Campanile and the Doge's Palace – all in the *Como and Venice* sketchbook – demonstrate how assured was Turner's transcription of the luminous Venetian atmosphere. The watercolours seem to be chiefly ex periments in the handling of colour and transient effects of light, designed to balance the more precise records of architecture, landscape, customs and costume being made at the same time. They look forward, also, to the Venetian oils produced in the 1830s and 1840s – for example, the unfinished *Venice, the Piazzetta with the Ceremony of the Doge Marrying the Sea* of *c.* 1835 (Fig. 24) or *Venice, from the Canale della Giudecca* of 1840 (Fig. 25).

Fig. 24 Venice, the Piazzetta with the Ceremony of the Doge Marrying the Sea

CANVAS, 91.5 x 122 CM. C. 1835. LONDON, TATE GALLERY

Fig. 25 Venice from the Canale della Giudecca, Chiesa di S. Maria della Salute etc.

CANVAS, 61 x 91.5 CM EXHIBITED 1840. LONDON, VICTORIA AND ALBERT MUSEUM

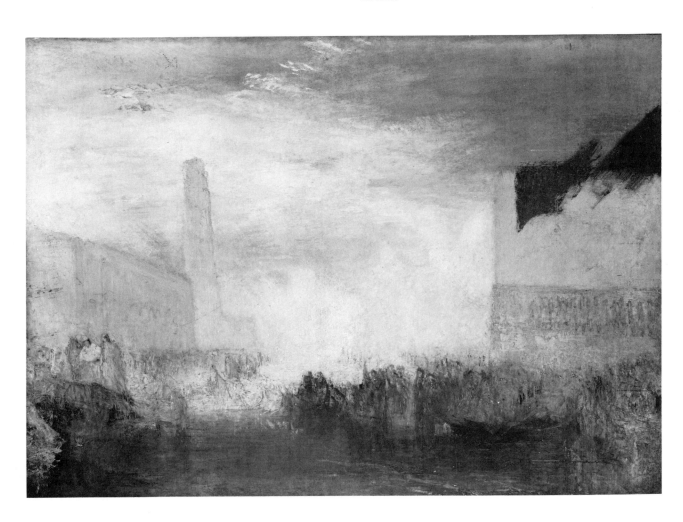

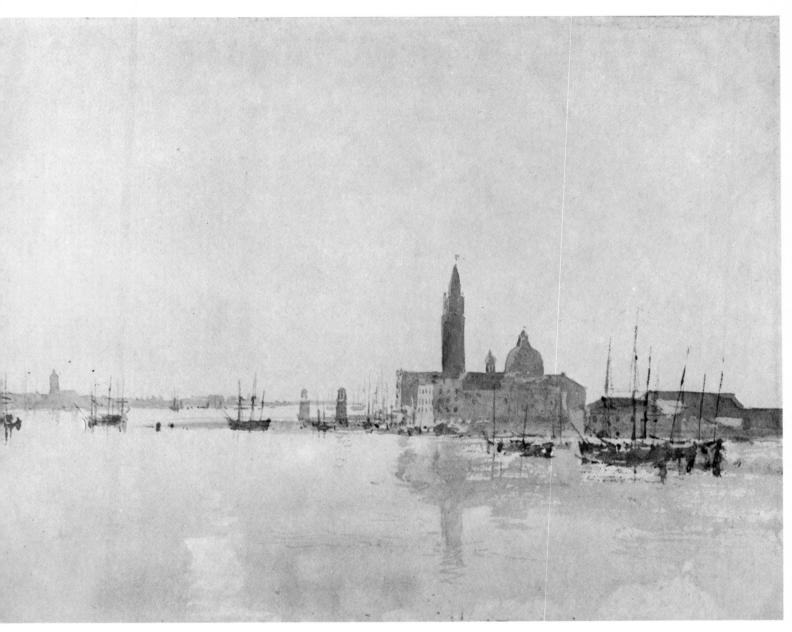

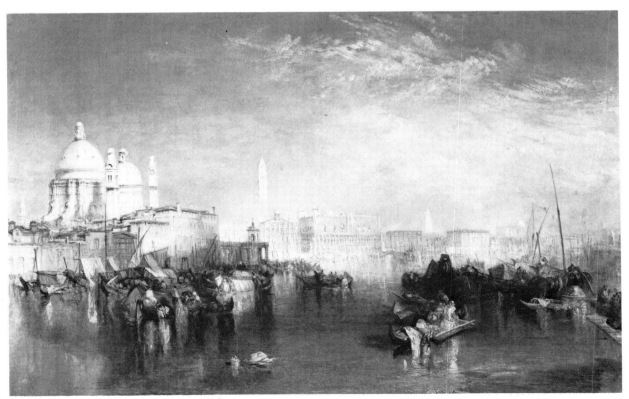

The Bay of Baiae, with Apollo and the Sibyl

CANVAS, 145.5 x 239 CM. EXHIBITED 1823. LONDON, TATE GALLERY

The subject is taken from Ovid's *Metamorphoses*, Book XIV, and it depicts the moment when Apollo, enamoured of Deiphobe, the Cumaean Sibyl, offers to give her whatever she should ask for. Deiphobe asks to live as many years as she has grains of sand in her hand, though she forgets to ask for the youth and beauty to go with it. Having turned down Apollo's offer of these in return for her love, Deiphobe's youthful good looks were to decay rapidly over the next thousand years she had to live. The picture was exhibited with the line 'Waft me to sunny Baiae's shore' and it was the second of the large exhibited canvases which resulted from Turner's first visit to Italy between August 1819 and February 1820.

Detail from 'The Bay of Baiae, with Apollo and the Sibyl' (Plate 16)

The exuberance of the artist's invocation to 'sunny Baiae' in *The Bay of Baiae* seems to have been matched by the richness of the colours which he used to recapture a recollection of the Italian landscape. John Constable said, referring to this 1823 exhibit, that 'Turner is stark mad – with ability – the picture seems painted with saffron and indigo'. Beyond its overall impact, looked at closely the picture reveals the detail which is characteristic of Turner's art: the white hare, a symbol of lust and thus directly related to the theme of the picture; the dashes of dark blue and the slight indications of undergrowth which give life to the shadows; the cataract with touches of red on the rocks and the slightly scumbled paint to indicate the spray above the water-fall; the sails and their reflections on the distant sea are mere flicks of white paint.

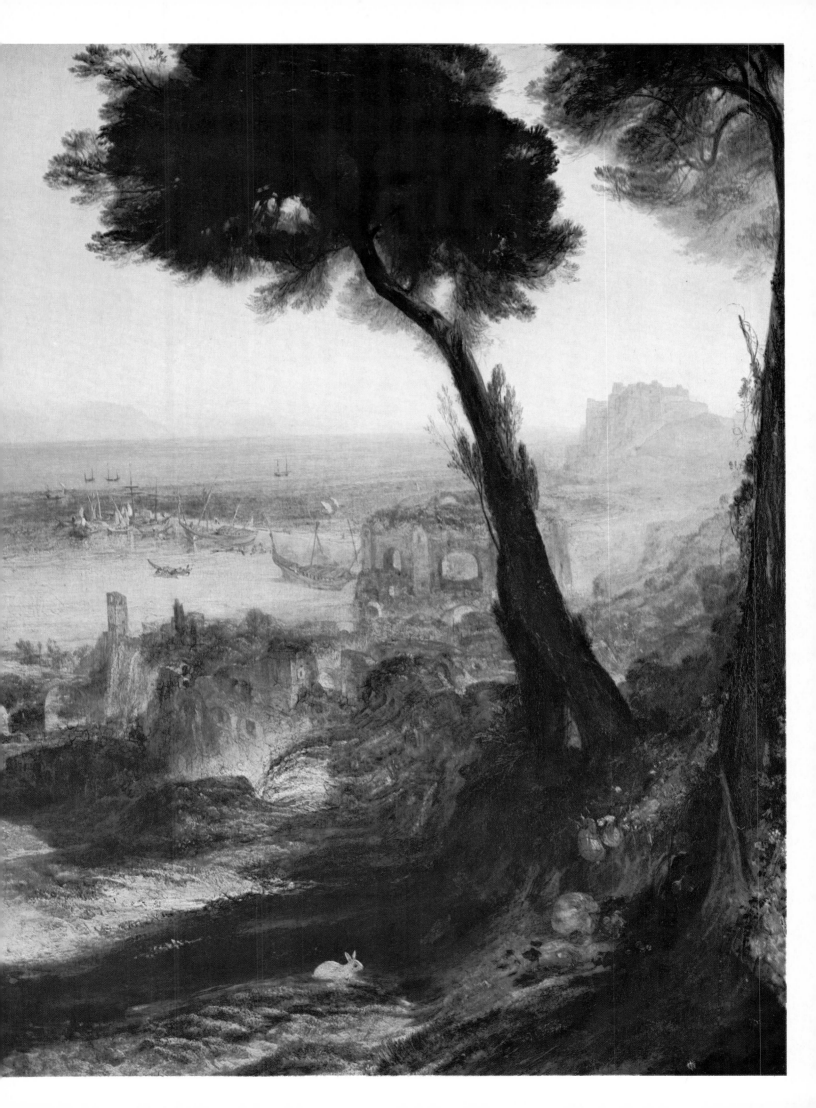

Storm-clouds: Sunset

WATERCOLOUR OVER PENCIL, 24 x 34 CM. C. 1825. LONDON, BRITISH MUSEUM

This watercolour, on a sheet of Whatman paper water-marked 1814, is one of several hundred unfinished water-colours which have been classified as 'Colour Beginnings'. On the evidence of style and subject matter they have been dated for the most part to the period 1820-1830. None was given a title by the artist and those they now possess are twentieth century inventions. The majority of these works would appear to be ideas, put down for possible future use, and, at the same time, experiments. In this instance, Turner's broad use of the medium – the sweep of the brush over wet paper, the colour lifted out in places with a dry brush, – perhaps sucked dry in his mouth – testify to the skill that lay behind the artist's apparent lack of constraint. That he valued such studies is evident from the number preserved in his Bequest.

19

Petworth Park: Tillington Church in the Distance

CANVAS, 64.5 x 145.5 CM. C.1828. LONDON, TATE GALLERY

George Wyndham, 3rd Earl of Egremont, was Turner's most important patron. In 1810 the artist exhibited a view of Petworth House commissioned by Egremont (see Fig. 26) – a work which lies securely within the tradition of country house portraits for which the paintings of Richard Wilson provided the model. The relationship to this tradition of the more daring *Petworth Park*, with its brilliant sky, its dramatic view, away from the house, looking west toward the estate village of Tillington and with the owner featured prominently in the middle distance, is quite clear: it exemplifies that sense of proprietorship and pride of ownership which had so often prompted the landed classes to commission work from an artist. It is emphasized in this particular instance by the subject matter of the companion works which are part of the same commission (see Plates 21-3). The dashing handling of the paint in the sky of *Petworth Park* is more restrained in the final version of the picture now at Petworth House; similarly, the perspective in the finished work is less dramatic, with the horizon brought nearer the picture plane and, amongst other changes, Egremont and his dogs have been replaced by a cricket match.

Fig. 26 Petworth, Sussex, the Seat of the Earl of
 Egremont: Dewy Morning

CANVAS, 91.5 x 121 CM. EXHIBITED 1810. PETWORTH HOUSE, H.M. TREASURY
AND THE NATIONAL TRUST

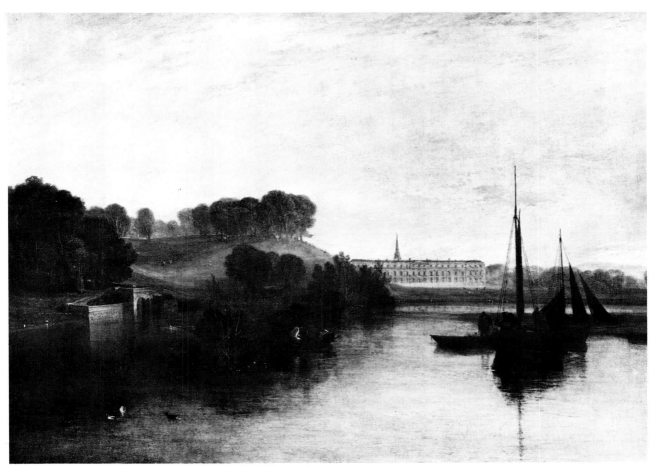

Interior at Petworth

WATERCOLOUR AND BODYCOLOUR ON BLUE PAPER, 14 x 19 CM.
C.1828. LONDON, BRITISH MUSEUM

Apart from producing the formal images of Petworth and its estate (see Plate 19 and Fig. 26) Turner also created a remarkable series of more than one hundred watercolour sketches which show a more private aspect of the house and its setting. Surprisingly, besides landscape studies – which one would expect – sketches in this group also record the rooms and the daily activities of the guests in what John Constable had called 'that house of art' – rich, particularly, in the productions of the old and the modern masters: *Petworth: the Drawing Room* (Fig. 27) shows Sir Joshua Reynolds's *Macbeth and the Witches* (1787-9) together with

other paintings, including family portraits. The artist Benjamin Robert Haydon described Petworth as a 'princely seat of magnificent hospitality': Turner's interiors, such as that shown in Plate 36, give a unique picture of this hospitality.

Fig. 27 Petworth: the Drawing Room
BODY-COLOUR ON BLUE PAPER, 14 x 19 CM. 1828? LONDON, BRITISH MUSEUM

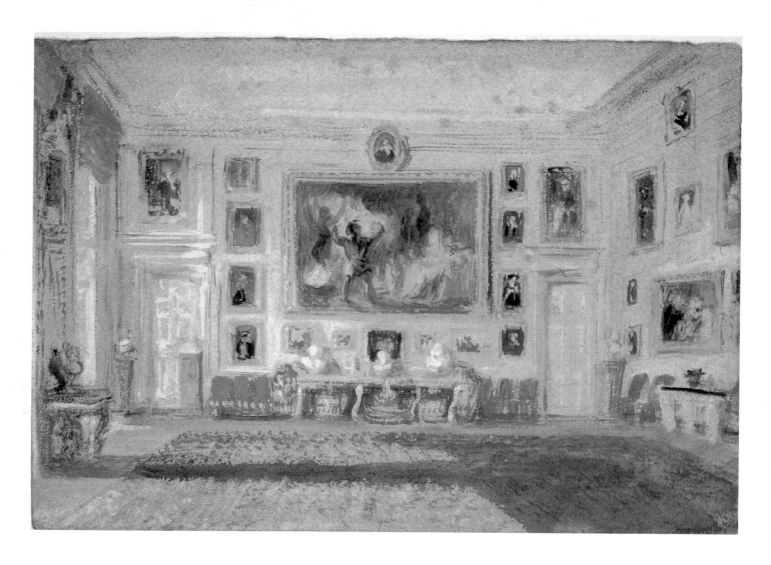

21

Chichester Canal

CANVAS, 65.5 x 134.5 CM. C.1828. LONDON, TATE GALLERY

Chichester Canal is one of a group of five full size sketches (see also Plates 19, 22, 23) four of which subsequently served as models for finished pictures still at Petworth. Specially designed to be hung below seventeenth-century portraits in the dining-room, the horizontal format of all the paintings is a consequence of their having to complement the widths of these portraits.

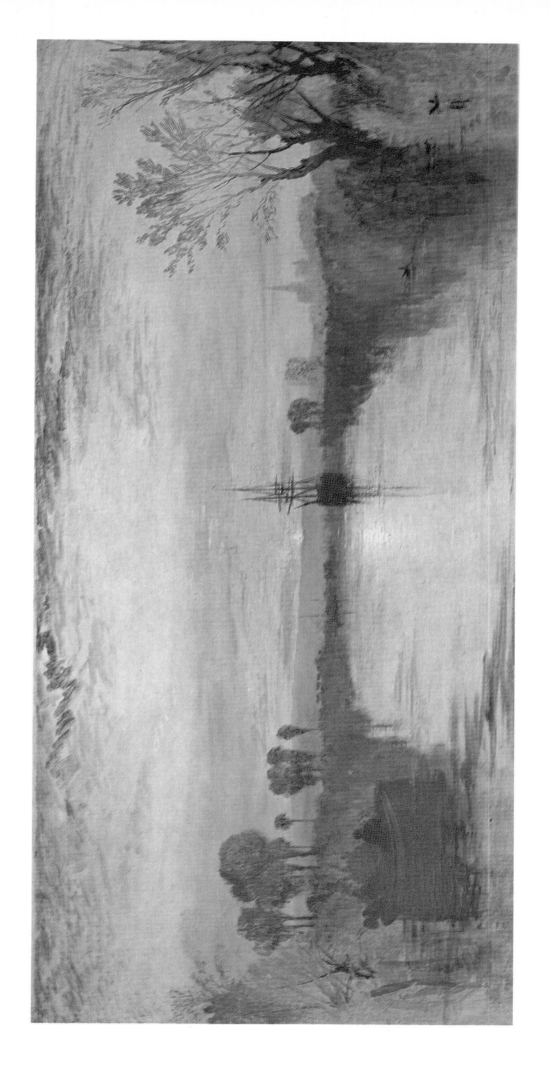

22

The Chain Pier, Brighton

CANVAS, 71 x 136.5 CM. C.1828. LONDON, TATE GALLERY

Apart from their size and format, the Petworth sketches of *c.* 1828 (see Plates 19, 21, 23), and their finished counterparts are united by the common theme of Lord Egremont's proprietorial interests – he had at one time a financial stake in both the Brighton Chain Pier and the Chichester Canal; the exception amongst the sketches is *A Ship Aground* (Plate 23). Common also to each composition is the dominance of the sun – a persistent allusion which seems to echo one artist's opinion, expressed in 1826, that Egremont in his munificence was 'literally like the sun'. The final version of this picture, *Brighton from the Sea* (Petworth House) retains the composition virtually unchanged but contains considerably more detail.

23

A Ship Aground

CANVAS, 70 x 136 CM. C.1828. LONDON, TATE GALLERY

Of all the Petworth landscapes Turner painted in *c.* 1828 *A Ship Aground* was the only work not to be used as the basis for a finished subject, though Turner developed its theme in two pictures exhibited at the Royal Academy in 1831; it was perhaps omitted from the final scheme because the subject was not connected with the Petworth estate. Other revisions also took place before the four pictures for the Petworth dining-room were finally installed in *c.* 1829. In fact, all the final versions show a greater degree of finish than the works now in the Tate Gallery, suggesting, together with other evidence, that these latter pictures might not have met with Egremont's approval.

Playing Billiards, Petworth

WATERCOLOUR AND BODY-COLOUR ON BLUE PAPER; 14 x 19 CM.
C.1828. LONDON, BRITISH MUSEUM

At the end of 1827 Lord Egremont – then in his late seventies – suffered a severe attack of pleurisy and although he recovered the illness must have caused some anxiety among his friends. The range of subjects upon which Turner dwelt in his Petworth sketches and their spontaneity, perhaps executed with the thought that such scenes might not be witnessed again, bear the marks of the artist's strong affection for a particular person and a particular place – a character trait that was known to his intimates but which fame has to a certain extent obscured for later generations. One contemporary described Turner as 'a firm, affectionate friend' and at Egremont's funeral in November 1837 he led the group of artists that walked before the hearse.

All the Petworth watercolours are painted on blue paper and some of them show signs of fading through exposure to strong light, as in *Playing Billiards* and *Interior* (Plate 20). A great number of the sketches show figures, often merely as loosely delineated silhouettes in vaguely defined spaces, and a number of them depict some of the other, unidentified, painters who were often guests at Petworth working at their easels (see Fig. 28). The small roman numerals visible at the bottom right hand corner of the blue paper indicate the number of the work in the inventory of drawings and watercolours in the Turner Bequest.

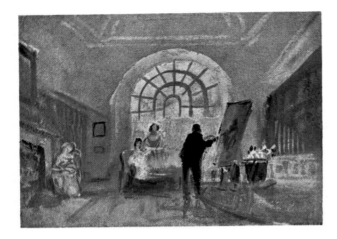

Fig. 28 Petworth: an Artist Painting in a Room with a Large Fanlight

BODY-COLOUR ON BLUE PAPER, 14 x19 CM. 1828? LONDON, BRITISH MUSEUM

Ariccia (?): Sunset

CANVAS, 60.5 x 79.5 CM. 1828? LONDON, TATE GALLERY

Between October 1828 and January 1829 Turner was in Rome for a second time. On this occasion, instead of repeating the extensive touring that he had undertaken in 1819, he remained for the most part in the city, working in a studio, exhibiting at least four canvases and completing a considerable number of watercolours and oil sketches; a sketch for the *Ulysses* of 1829 (Plate 27) is to be found in the latter group. *Ariccia* (the identification with the hill town near Rome is only tentative) is one of a group of seven sketches which were originally painted on one large canvas that was rolled up for the journey back to London: the obvious vertical craquelure in the paint is a result of this rolling up.

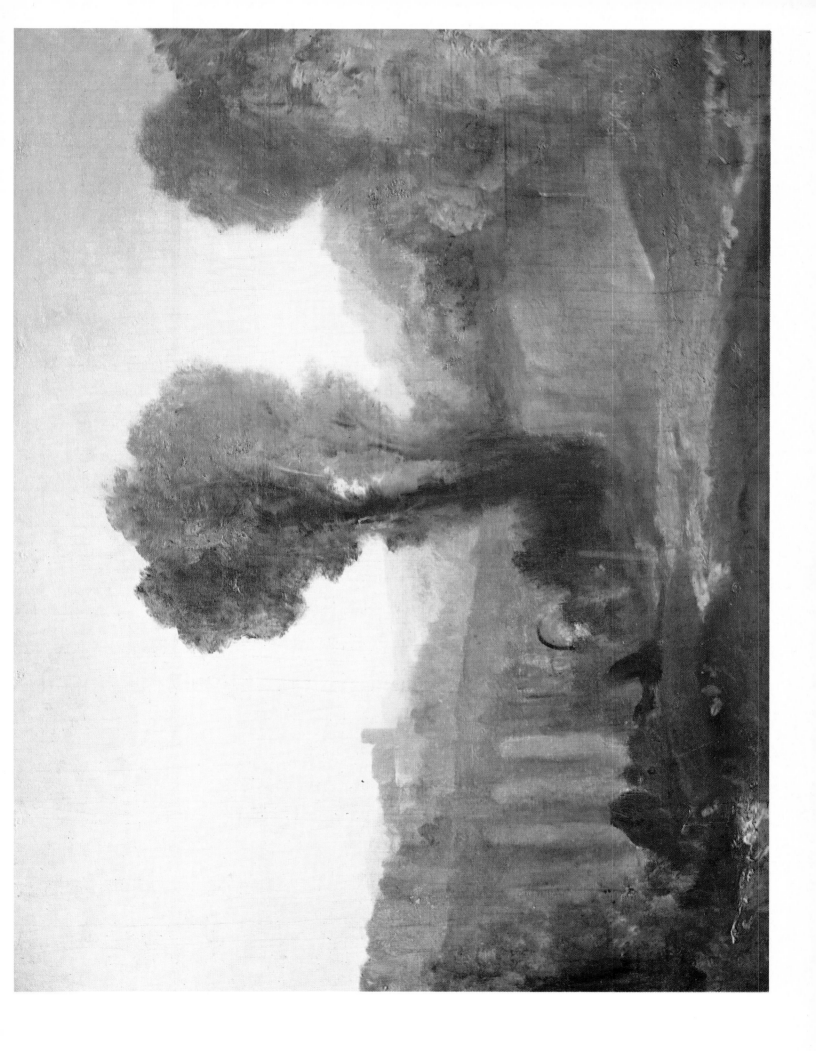

Archway with Trees by the Sea

CANVAS, 60 x 87.5 CM. 1828? LONDON, TATE GALLERY

Archway with Trees by the Sea, like *Ariccia* (Plate 25) and the other fourteen works classified as Roman Sketches, is characterized by its broadly applied flat colouring. None of the works in this group can be regarded as more than a compositional sketch and, with one exception – a sketch for *Ulysses* – none relates directly to a finished picture. *Coast Scene near Naples* (Fig. 29) is one of another group of ten smaller oil sketches, on millboard, which can probably associated with Turner's second visit to Italy.

Fig. 29 Coast Scene near Naples

OIL ON MILLBOARD, 41 x 60 CM. 1828? LONDON, TATE GALLERY

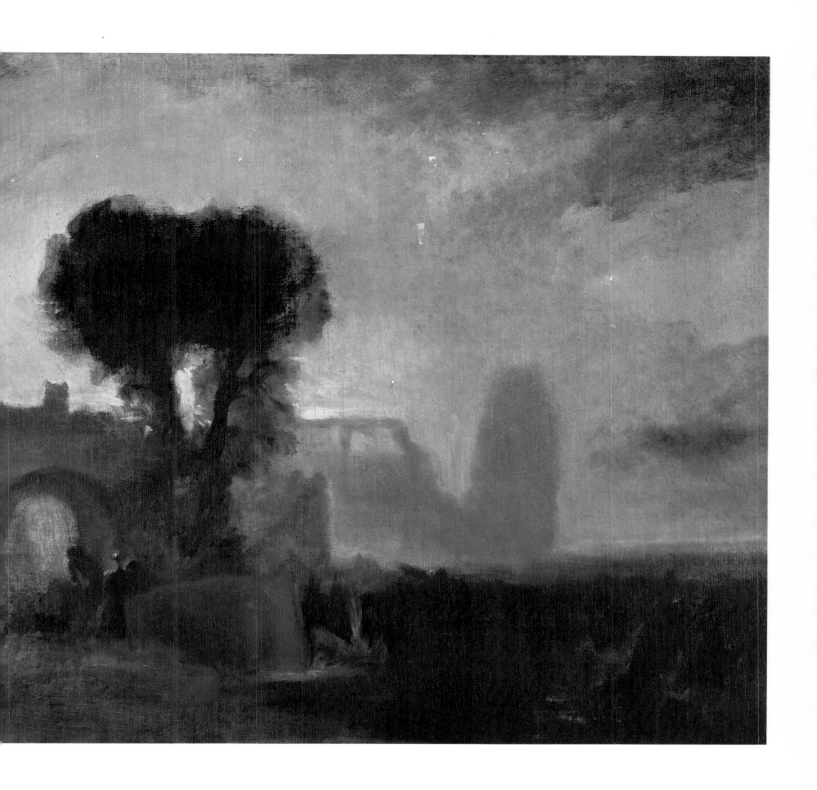

Ulysses Deriding Polyphemus – Homer's Odyssey

CANVAS, 132.5x203CM. EXHIBITED 1829. LONDON, NATIONAL GALLERY

Every year between 1829, following his return from Italy, and 1846 Turner exhibited at least one picture inspired by Italy: *Ulysses Deriding Polyphemus* was the first of these works. The heightening of the colour in this painting – which can be seen as a natural progression from that of *The Bay of Baiae* (Plate 16) – has reached a new extreme. This was undoubtedly a consequence of Turner's reactions to both the light and atmosphere of Italy and to the works of art he was looking at during his stay there in 1828-9 – when he produced a sketch for *Ulysses* – as well as his having a studio in Rome where he could experiment with the range of his palette. The change was noticeable enough for one contemporary critic to write of the 'unnatural tawdriness' of the picture and its 'colouring run mad'; John Ruskin was to call it later 'the *central picture* in Turner's career'.

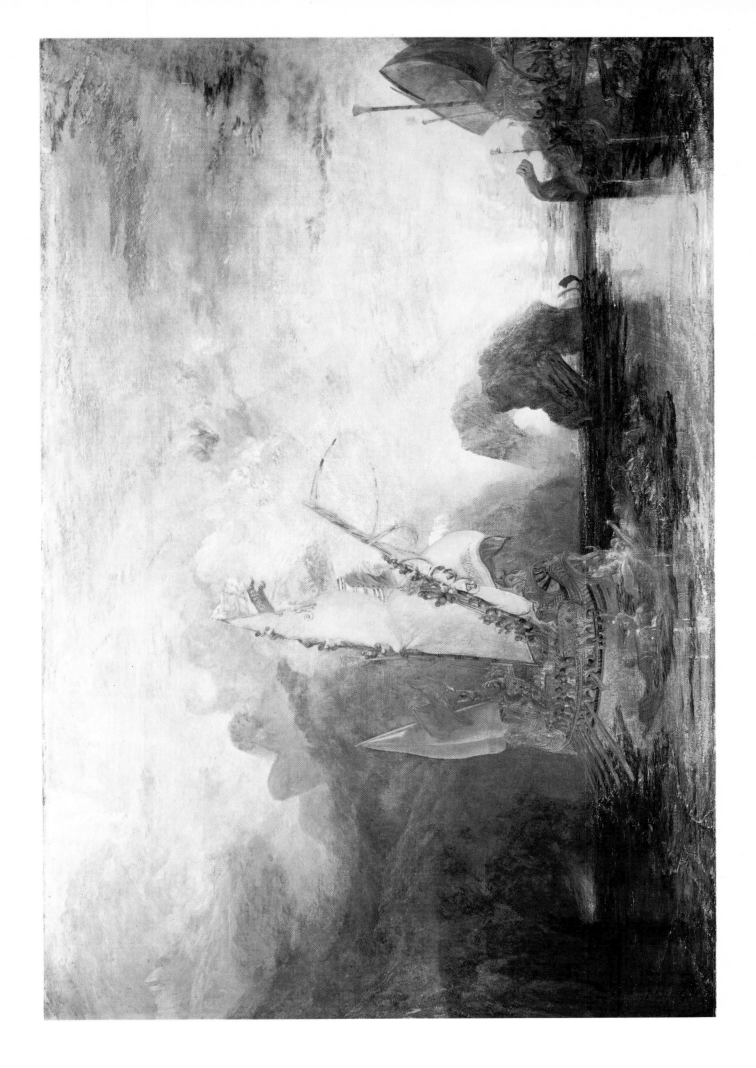

Detail from
'Ulysses Deriding Polyphemus
– Homer's Odyssey' (Plate 27)

The subject of *Ulysses* is taken from Book IX of *The Odyssey* in which Ulysses, having been driven onto the coast of Sicily is imprisoned, with twelve of his companions, by Polyphemus, king of the Cyclops and son of Poseidon. Polyhemus feasted on two men morning and evening until Ulysses made him drunk and put out his eye with a firebrand, escaping to his ship by hiding among the sheep and goats kept by Polyphemus. Ulysses is shown on board his ship whilst the blinded giant invokes Poseidon's vengeance on the fleeing warrior. Just discernable on the banner attached to the main mast of the vessel is a representation of the wooden horse being pushed into the city of Troy — a stratagem for which Ulysses is said to have been responsible.

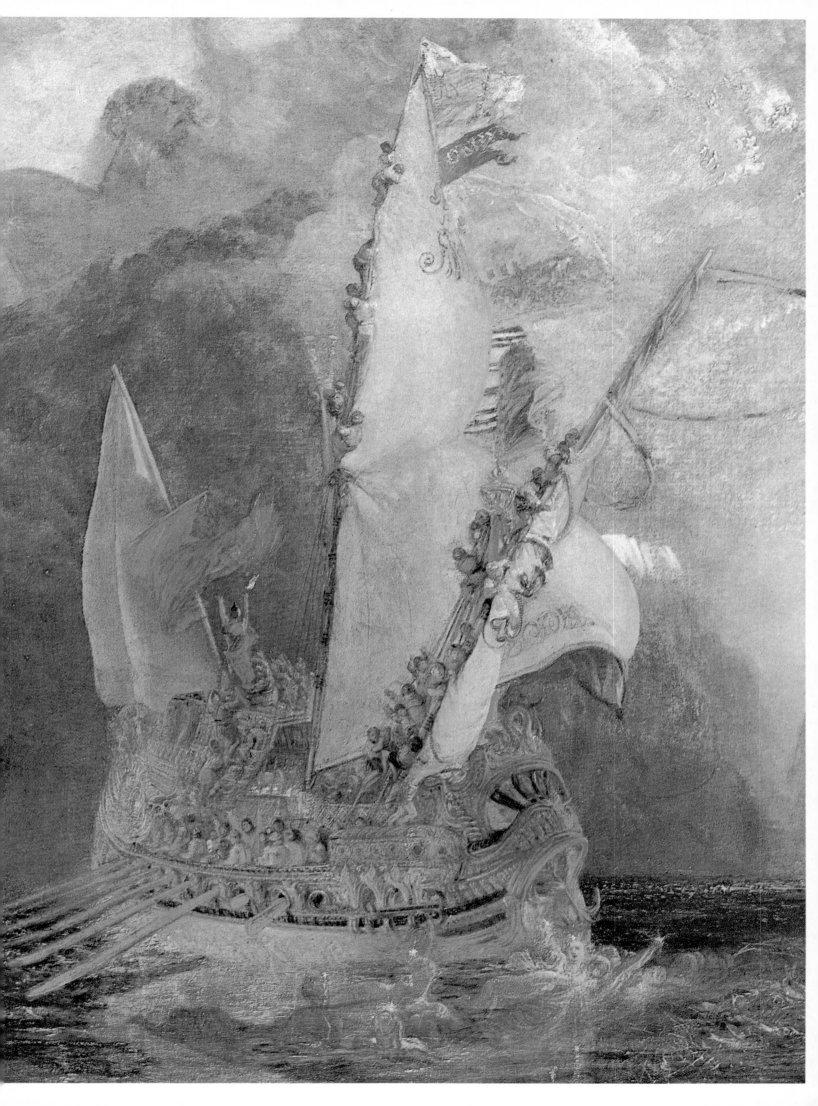

Death on a Pale Horse (?)

CANVAS, 60 x 75.5 CM. C.1825–30. LONDON, TATE GALLERY

The theme of death is to be found in a number of Turner's pictures, for example, *The Tenth Plague of Egypt* (1802; Tate Gallery), *The Field of Waterloo* (1818; Tate Gallery) and *Slavers throwing overboard the Dead and Dying* (1840; Plate 43). In the case of *Death on a Pale Horse*, taken from *Revelations* Chapter VI, the artist was dealing with the subject in a manner which was much closer to the mood of the 'terrible sublime' evoked by several earlier artists who had turned to the same source: Turner would undoubtedly have known the most famous version of the subject, a vast canvas by Benjamin West which was first shown in London in 1817. However, Turner's interpretation, with Death lying prone across the back of a rearing horse, is markedly different from the triumphant motif usually found in rendering of the subject directly inspired by *Revelations*. For one aspect of the symbolism of colour in relation to death see Ruskin's comment under *The Fighting 'Temeraire'* (Plate 41).

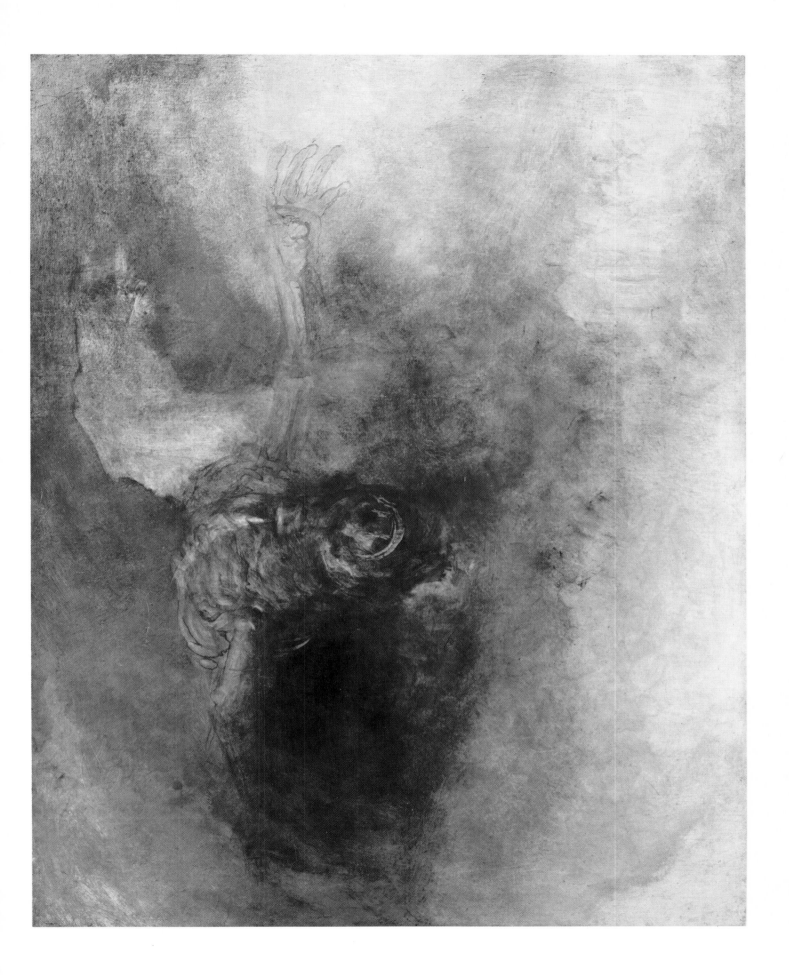

Scene on the Loire

WATERCOLOUR AND BODY-COLOUR ON BLUE PAPER, 14 x 19 CM.
1826–30. OXFORD, ASHMOLEAN MUSEUM (RUSKIN SCHOOL
COLLECTION)

The popularity of small, elegantly produced volumes called Annuals, illustrated with engravings and usually issued in time to catch the Christmas trade, provided an expanding outlet for the work of painters and engravers until the middle years of the nineteenth century. Turner, inevitably, was closely involved in a number of such enterprises and three volumes entitled *Turner's Annual Tour*, containing steel engravings after his watercolours, appeared between 1833 and 1835. The illustrations were based on sketches made by Turner during his various travels in France: a steel engraving 'Chateau of Amboise' – one of twenty-one views published in *Turner's Annual Tour – The Loire* of

1833 – is illustrated in Figure 30 and the original watercolour from which it was taken can be seen in Figure 6. *Scene on the Loire*, though never published, relates to this same Annual Tour. The work was owned by Ruskin who described it on different occasions as an 'unsurpassable example of water-colour painting' and 'the loveliest of all' the Loire drawings.

Fig. 30 Chateau of Amboise

ENGRAVING ON STEEL BY J.B. ALLEN, AFTER TURNER, 9.5 x 14.5 CM. 1833.
LONDON, BRITISH MUSEUM

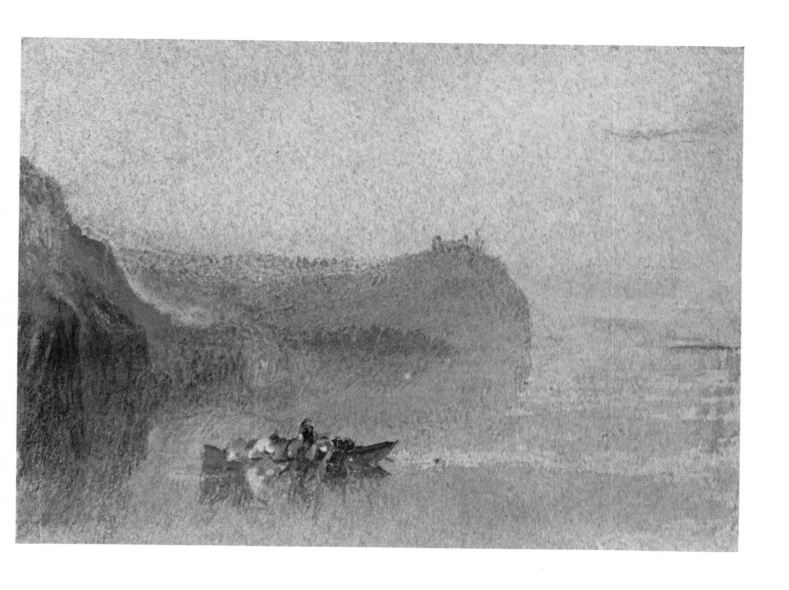

Rocky Bay with Figures

CANVAS, 91.5 x 124.5 CM. C.1830. LONDON, TATE GALLERY

This composition would seem to be related to the land-scape depicted in *Ulysses Deriding Polyphemus* (Plate 27) but, whilst it has been suggested that the picture might have been intended to illustrate another episode in the life of Ulysses, the detail is too sketchy for any particular sub-ject to be identified. The handling of the paint is very free – characteristic of Turner's increasingly vigorous and inventive use of his media as he grew older; a similar freedom can also be seen, for example, in *Death on a Pale Horse* (Plate 29). The thin, fluid paint in the left foreground has been scraped away while it was still wet – in much the same way that the crown on the head of Death in *Death on a Pale Horse* has been delineated. There is a creamy impasto in the area of the sky behind the tree on the cliff-top and broad, full, brush strokes, clearly visible on the paint sur-face, give some idea of the artist's impulsive energy.

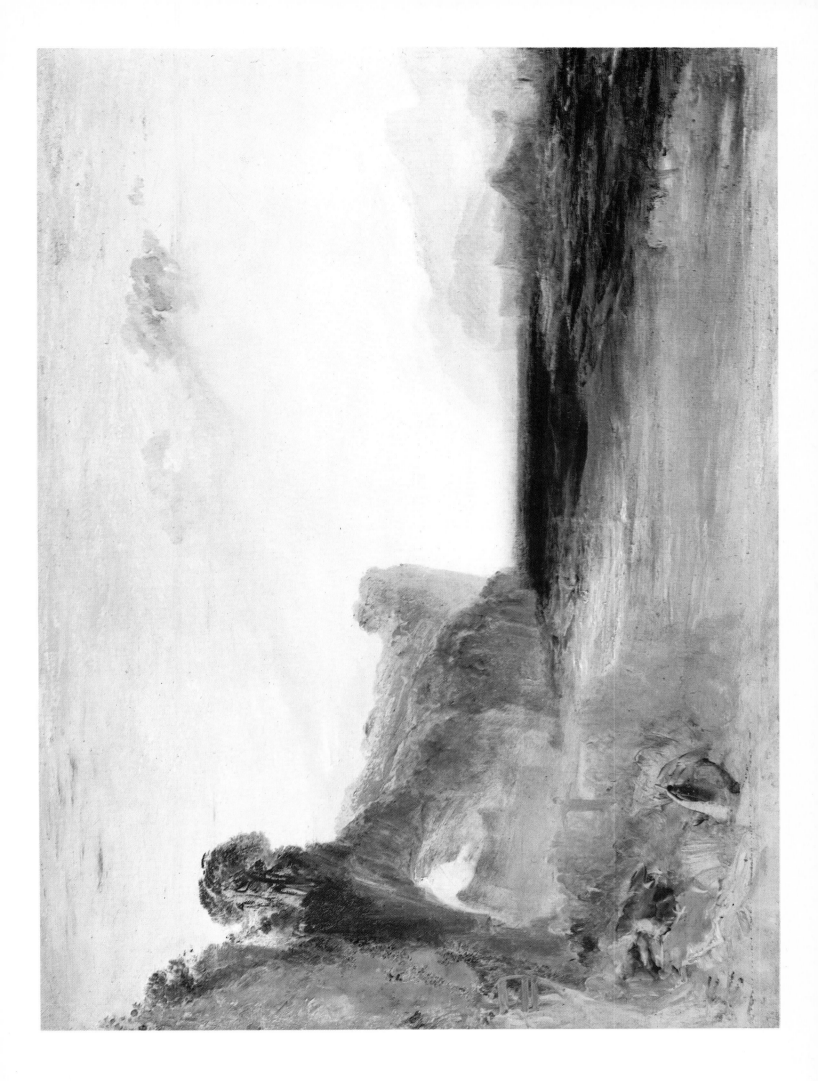

The Evening Star

CANVAS, 92.5 x 123 CM. C.1830. LONDON, NATIONAL GALLERY

It has been suggested that this painting was inspired by the coastal scenes painted in France by the young English artist Richard Parkes Bonington who had died at the age of twenty-six in 1828. Bonington's prodigious talent was admired by Turner and he must have known the views of flat expanses of beach, populated by a few figures and charactered by a particular delicacy of touch, which formed an important part of Bonington's output.

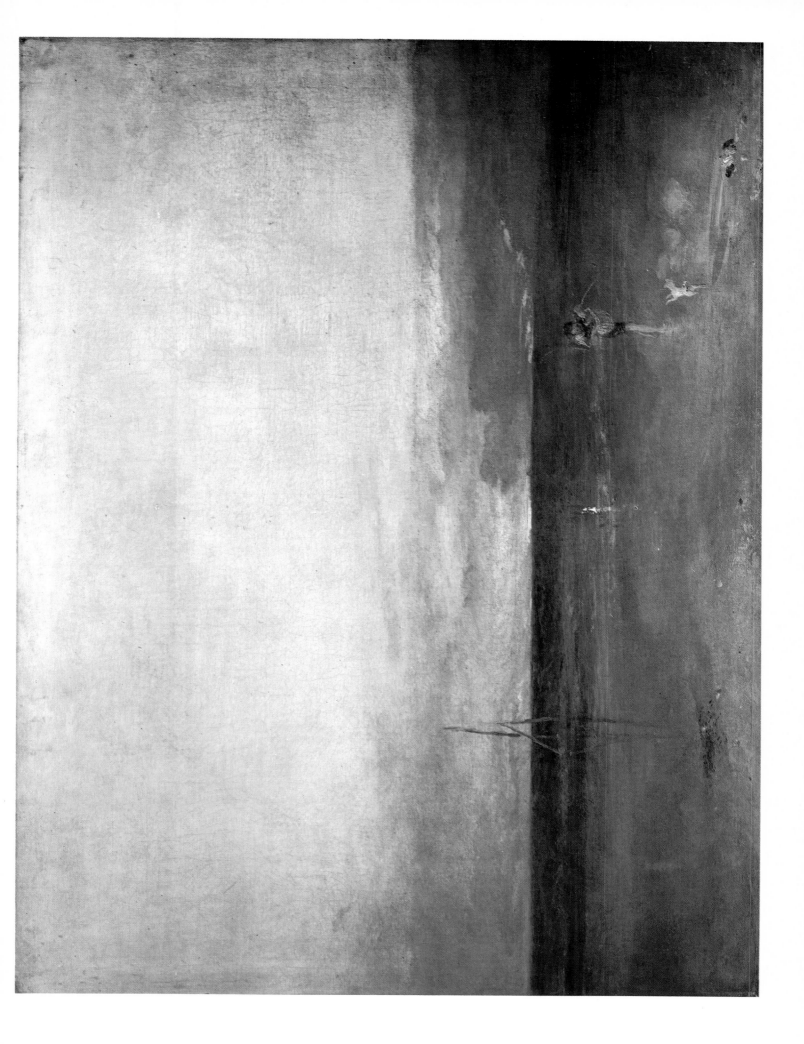

Venice

CANVAS, 90 x 122 CM. EXHIBITED 1834. WASHINGTON, D.C.,
NATIONAL GALLERY OF ART (WIDENER COLLECTION)

Though having visited Venice in 1819 (see Plates 14, 15)
and having worked on a large, unfinished, oil painting of
The Rialto following his return to England in 1820,
Turner was not to exhibit an oil painting of a Venetian sub-
ject until May 1833. *Venice,* painted after a second visit to
the city during the summer of 1833, was the first of more
than twenty Venetian pictures which were shown at the
Royal Academy almost every year until 1846. This period
embraced the artist's third and final stay in Venice in 1840
which saw the production of a remarkable series of water-
colours such as Figure 31. The oils, together with the
watercolours, form a unique exploration of the light and
the architecture which is the city's particular glory. *Venice*
was painted for a Manchester textile manufacturer,
Turners' price for it being £350.

Fig. 31 Venice: the Grand Canal

WATERCOLOUR OVER SLIGHT PENCIL OUTLINE, PEN AND RED AND BLUE
INK AND SOME HEIGHTENING WITH WHITE, 21.5 x 31.5 CM. 1840. OXFORD,
ASHMOLEAN MUSEUM

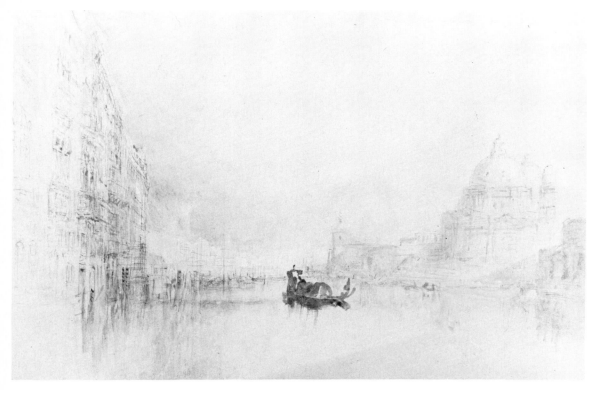

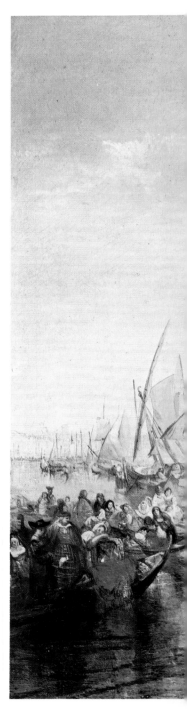

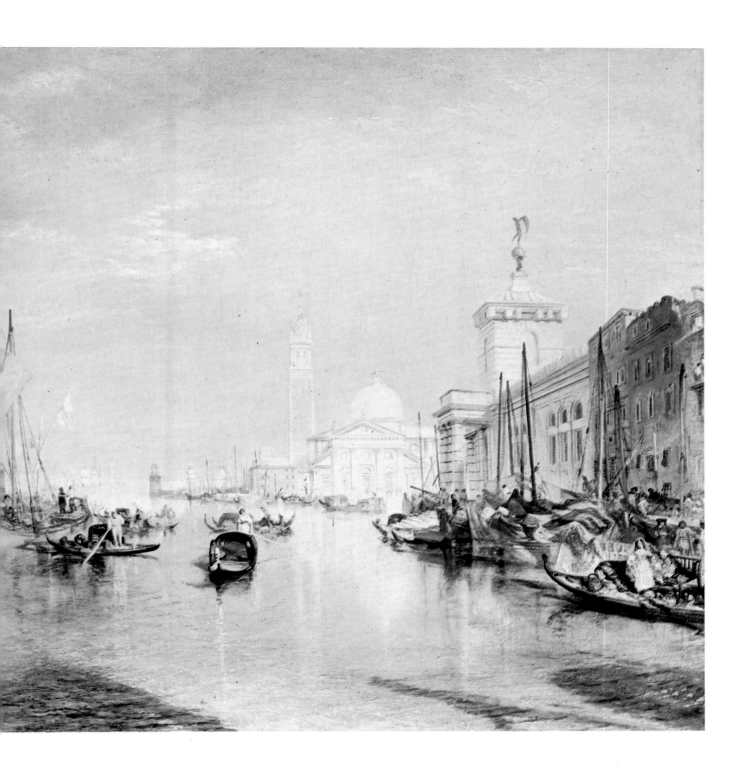

The Burning of the Houses of Parliament

WATERCOLOUR, 23 x 32 CM. 1834. LONDON, BRITISH MUSEUM

The Houses of Parliament were destroyed by fire on the evening of 16 October 1834; Turner was there and he recorded the scene from several different viewpoints in a number of pencil sketches and also in a series of nine watercolour studies, one of which is illustrated here. The subject inevitably recalls one of Turner's earliest exhibits, *The Oxford Street Pantheon after the Fire of 14 January 1792* (Fig. 32) and a comparison of the two works demonstrates how extraordinary had been the development of his eye and his technique during the intervening years. In the early work he is primarily concerned with producing a record of a serious fire but in the *Houses of Parliament* sketches the sublimity of a great conflagration is captured in the violent movements of the brush and in the glaring contrasts of colour.

One contemporary described the energy with which Turner handled his materials when producing a watercolour: ' . . . he began by pouring wet paint on to the paper till it was saturated, he tore, he scratched, he scrabbled at it in a kind of frenzy and the whole thing was chaos.'

Fig. 32 The Oxford Street Pantheon after the Fire of 14 January 1792

WATERCOLOUR OVER PENCIL, 39.5 x 51.5 CM. EXHIBITED 1792. LONDON, BRITISH MUSEUM

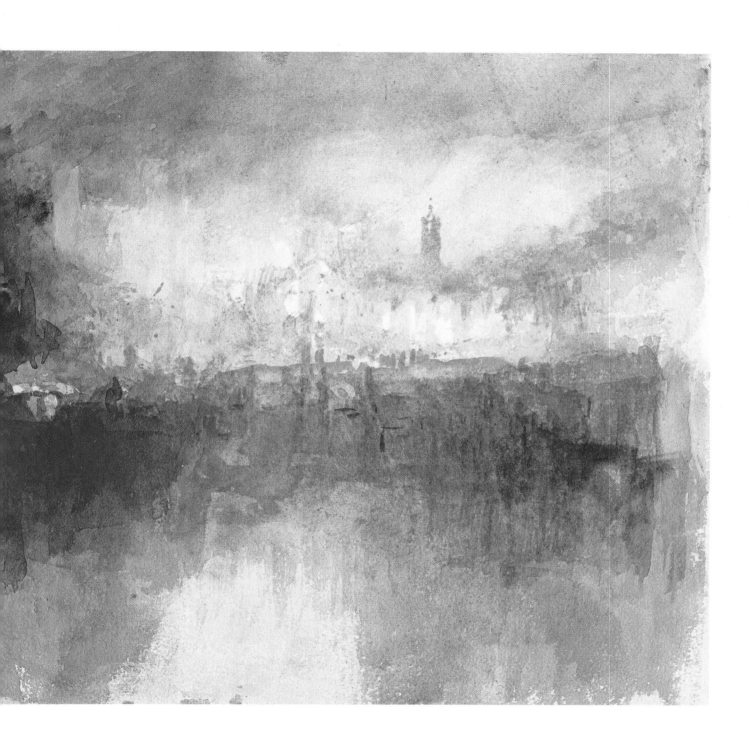

The Burning of the Houses of Lords and Commons, October 16, 1834

CANVAS, 92.5 x 123 CM. EXHIBITED 1835. CLEVELAND, OHIO,
CLEVELAND MUSEUM OF ART, BEQUEST OF JOHN L. SEVERANCE

From his vivid impressions of the fire that destroyed the
Houses of Parliament in 1834 Turner produced two large
canvases – the second of which was exhibited at the Royal
Academy during the summer of 1835. The critic of *The
Times* noted that in this instance the artist's 'fondness for
exaggeration . . . led him into faults which nothing but his
excellence in other respects could atone for.'

Fig. 33 Detail from 'The Burning of the Houses of
 Parliament'

WATERCOLOUR, 23.5 x 32.5 CM. 1834. LONDON, BRITISH MUSEUM

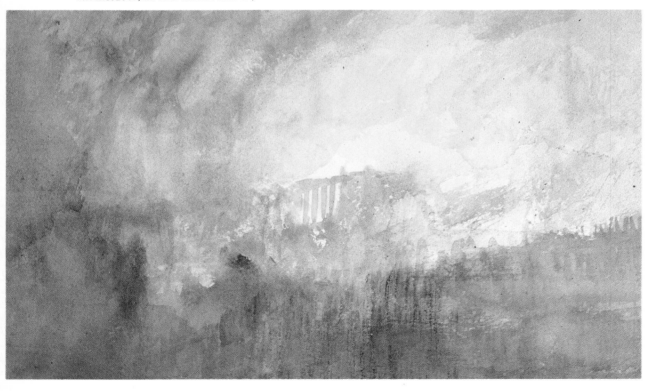

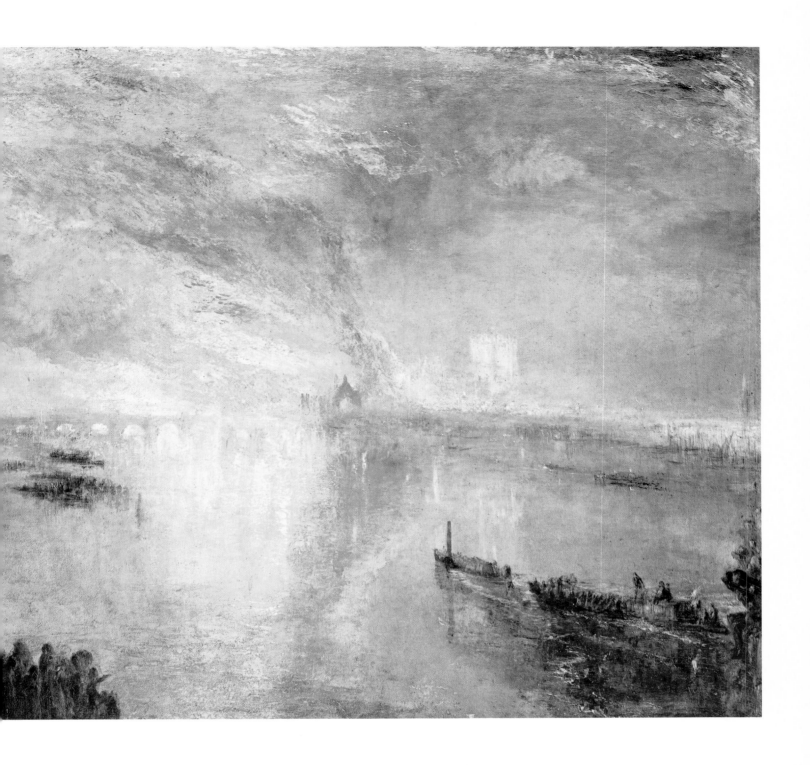

Dinner in a Great Room
with Figures in Costume

CANVAS, 91 x 122 CM. C.1830–5. LONDON, TATE GALLERY

This work has been associated with Turner's visits to Pet-
worth, showing, in a rather grander way, the social life that
he had recorded there in the much smaller watercolours
(Plates 20, 24). Here and in Figure 34, the elaborate
costumes of the participants suggest a *tableau vivant*. This
entertainment – a popular feature of many house parties at
this period – very often consisted of static renderings of
well-known paintings and living artists were occasionally
called in to help with the arrangement of the figures. The
Rembrandtesque figure in silhouette against the shaft of
light to the left of the picture might perhaps be an allusion
to the inspiration for the *tableau*.

Fig. 34 Petworth: A Group of Ladies Conversing

BODY–COLOUR ON BLUE PAPER, 14 x 19 CM. 1828? LONDON, BRITISH MUSEUM

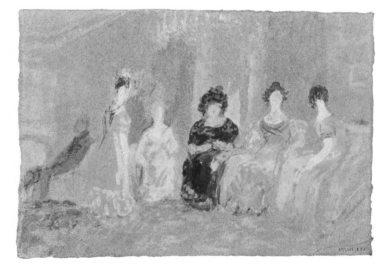

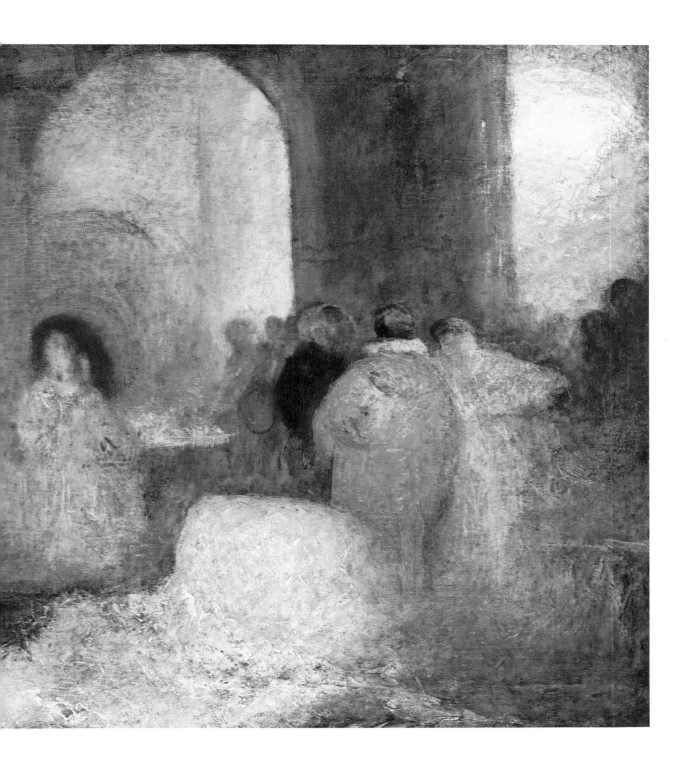

Keelmen Heaving in Coals by Night

CANVAS, 90 x 122 CM. EXHIBITED 1835. WASHINGTON, D.C.,
NATIONAL GALLERY OF ART (WIDENER COLLECTION)

Keelmen was painted for the industrialist Henry McConnell as a companion to the *Venice* of 1834 (Plate 33); the artist was paid £300 for the picture. The composition is closely based on a watercolour of 1823, *Shields on the River Tyne*, one of seventeen designs after Turner which were engraved in mezzotint for the publication *The Rivers of England*. Whilst the watercolour is clearly a topographical design it has been suggested that the two pictures of *Keelmen* and *Venice* might have been designed to contrast the burgeoning activity in an English industrial port with the decline of the once great port of Venice.

The critic of the *Literary Gazette* noted, when the picture was exhibited, the 'flood of glorious moon-light wasted upon dingy coal-whippers, instead of conducting lovers to the appointed bower.' The reviewer in *The Athenaeum* commented that 'we have often seen men working by torch-light on the river, but who can hope to see such scenes as present themselves to the eye of this artist? At the first glance, the word "extravagant" rose to our lips; but as we lingered before the scene, other feelings triumphed, and we could not help pronouncing it a striking, if not a wondrous performance.'

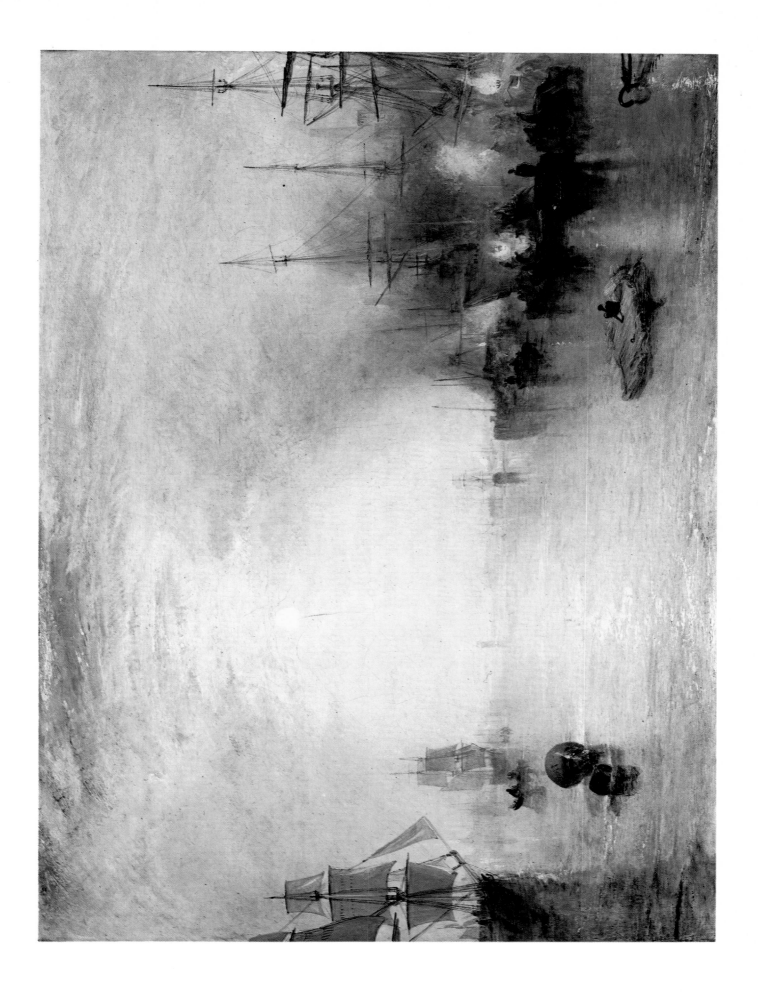

Fire at Sea

CANVAS, 171.5 x 220.5 CM. C.1835. LONDON, TATE GALLERY

Turner's first biographer, Walter Thornbury, mentions
one instance of the artist 'studying a burning ship at sunset
(unfinished oil picture).' In addition, a number of works in
oil and in one of the Turner Bequest sketchbooks deal with
ships on fire; but this unfinished picture, which from its
size was probably ultimately intended for exhibition, is
unusual amongst Turner's shipwreck scenes. Not only is
fire associated with an image which Turner has already ex-
plored – for example in *The Wreck of a Transport Ship*
(Plate 8) – but the drama centres upon the plight of women
and children, a theme well calculated to touch the sen-
sibilities of an early nineteenth-century audience.

Fig. 35 Breakers on a Flat Beach

CANVAS, 90 x 121 CM. C. 1830–5. LONDON, TATE GALLERY

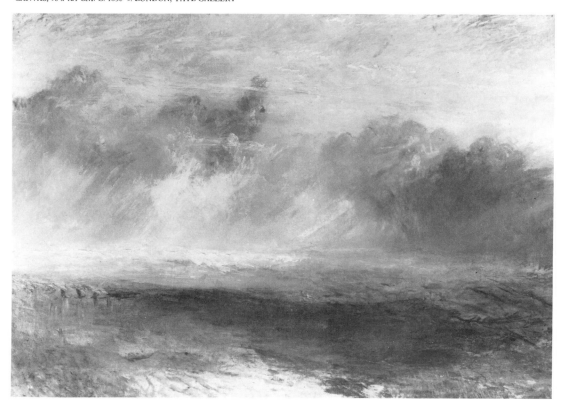

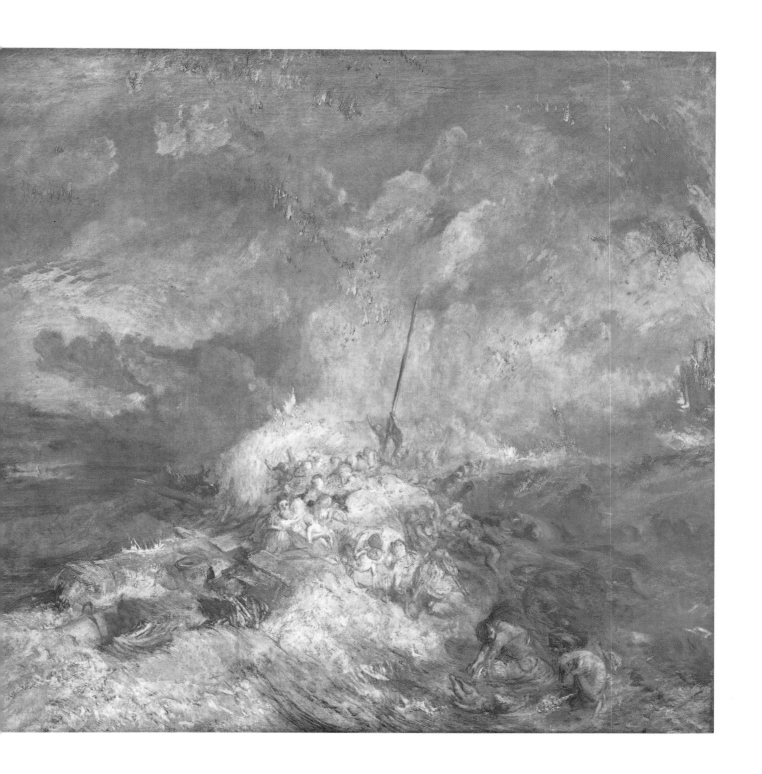

The Parting of Hero and Leander – from the Greek of Musaeus

CANVAS, 146 x 236 CM. EXHIBITED 1837. LONDON, NATIONAL GALLERY

The Greek poet *Musaeus*, in his poem *Hero and Leander*, describes the love between Hero, a priestess of Venus at Sestus, and Leander who lived in the Asian city of Abydos, on the opposite side of the Hellespont. Such was their love for each other that Leander would swim nightly across the Hellespont while Hero would direct his course by holding a torch on the top of a high tower. One stormy night when swimming to Hero Leander was drowned and, in despair, Hero threw herself from her tower into the sea. Turner's picture shows Leander about to set off, at dawn, on a return swim. Such is the wealth of pure landscape produced by the artist that it is easy to overlook the subtleties and the narrative force in the works that derive from literary sources. Here, the Nereides, or nymphs of the sea, who could create waves and calm them and who would bear away Leander's body, are shown in their grotto on the right hand side of the composition; and the imminent tragedy is suggested by the lowering sky, the rising waves dashing on the shore and the moon in partial eclipse.

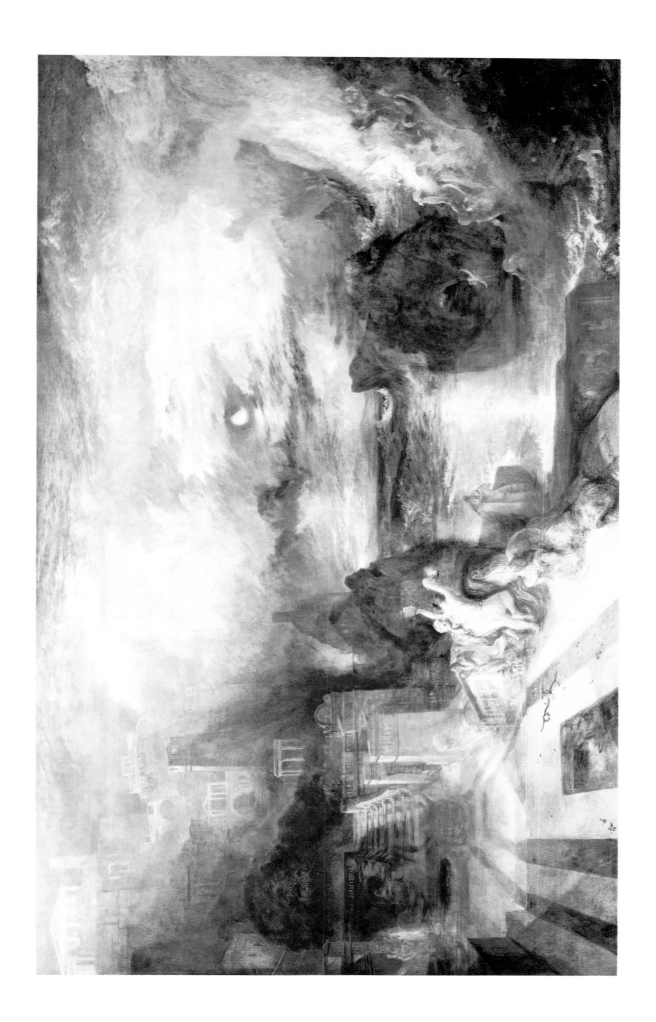

Detail from 'Interior at Petworth'

CANVAS, 91 x 122 CM. C.1837. LONDON, TATE GALLERY

One of a number of interiors which can be associated with Petworth (see also Plate 36). It has been suggested that this work was inspired by the death of Turner's patron, Lord Egremont, in 1837. The state of chaos which reigns, the flood of light in the distance which recalls one of the small watercolours of *c.* 1828 showing Flaxman's sculpture of the Archangel Michael and Satan, the discernable coat-of-arms below what appears to be an open coffin and the dogs which also feature – running to their master – in *Petworth Park* (Plate 19), are all pointers to such an interpretation. If a resurrection was implied, the wife of another artist patronized by Egremont, referring to a commission completed after the Earl's death and later taken down to Petworth, unwittingly voiced a similar thought: 'unless *dear* Lord Egremont rises one moonlight night & takes a peep at your picture . . . it will never be valued . . . as it ought to be, but I flatter myself the dearest Lord will look on it ere the moon be on its wane.'

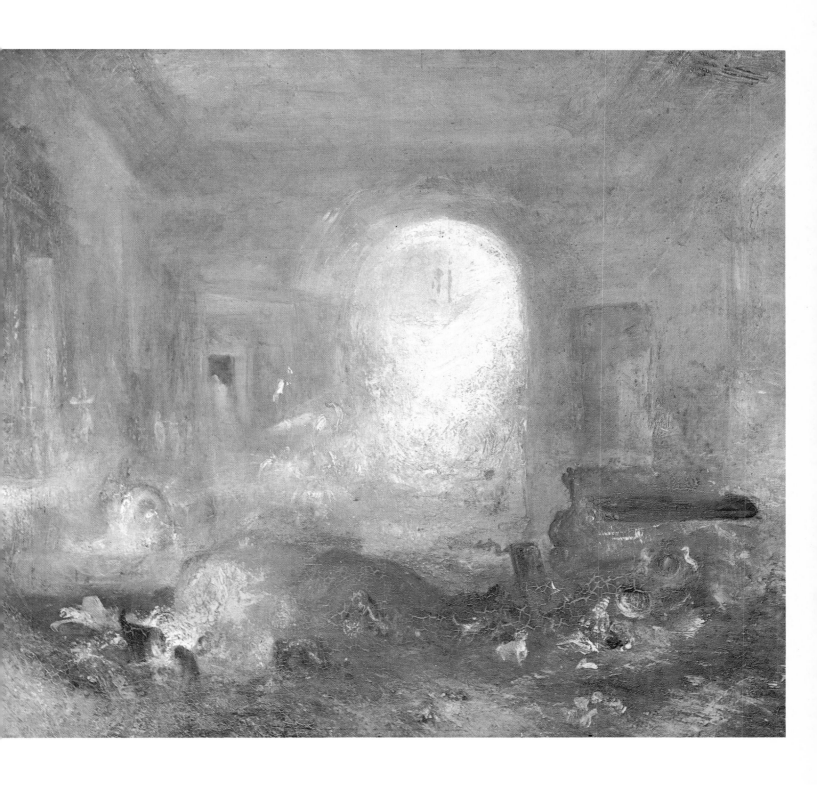

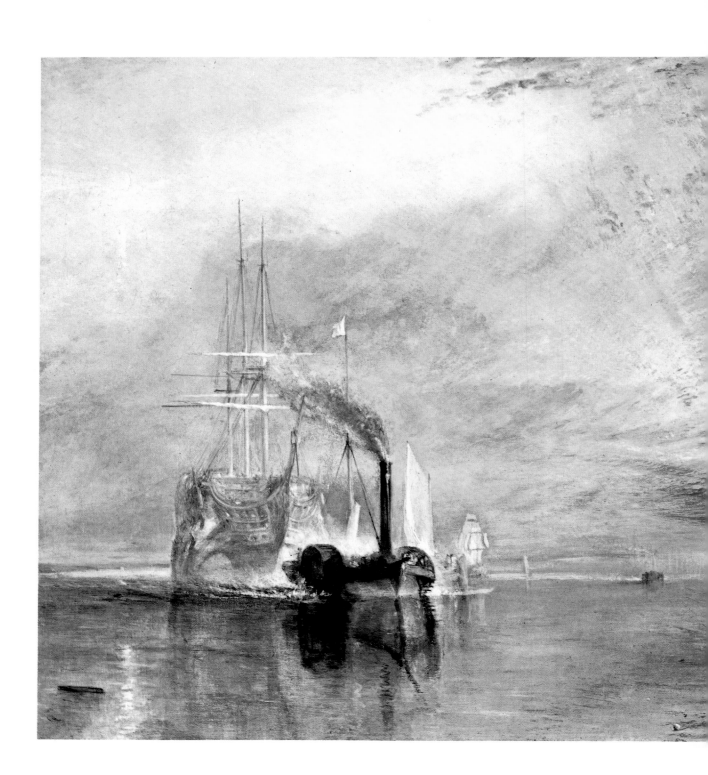

The Fighting 'Temeraire', Tugged to her Last Berth To Be Broken up, 1838

CANVAS, 91 x 122 CM. R.A., 1839. LONDON, NATIONAL GALLERY

The *Temeraire*, a ship of ninety-eight guns, was at the Battle of Trafalgar on 21 October 1805; she was next to the *Victory* and followed Nelson into action. Turner had dealt with the subject of Trafalgar in a picture exhibited in 1806 (Fig. 36) and here, in *The Fighting 'Temeraire'*, the artist commemorates the final journey of the old warship as she is towed up the Thames to the breaker's yard at Rotherhithe. The reference to the Napoleonic wars, implicit in the subject, recurs in *War. The Exile and the Rock Limpet* (for which see under Plate 44) of four years later, but the wider theme of national decline, upon which the artist seems to be dwelling in this picture, can be seen very much as a development from works such as *Dido Building Carthage* of 1815 (Plate 11) or its pendant *The Decline of the Carthaginian Empire* of 1817. The symbolism of the sunset in *The Fighting 'Temeraire'* was commented upon by critics at the time of its exhibition and Ruskin remarked that Turner 'was very definitely in the habit of indicating the association of any subject with circumstances of death . . . by placing it under one of his most deeply *crimsoned* sunset skies'.

An indication, perhaps of Turner's special feeling for the subject is the pointed alliteration of the title which complements that of the lines accompanying the picture:

The flag which braved the battle and the breeze,
No longer owns her.

Fig. 36 The Battle of Trafalgar, as Seen from the Mizen Starboard Shrouds of the Victory

CANVAS, 171 x 239 CM. EXHIBITED 1806. LONDON, TATE GALLERY

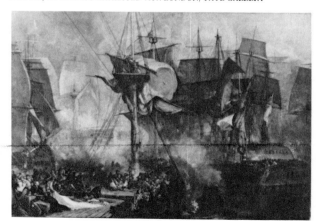

Sunrise, with a Boat between Headlands

CANVAS, 91.5 x 122 CM. C.1835–40. LONDON, TATE GALLERY

In the late, unfinished and unexhibited, oils, with their washes of paint on a white ground, Turner's work comes closest in style, feeling and technique to his watercolours of the same period. Dark colours are almost eliminated from his palette; light is reflected, through the thin glazes, from the ground. While he was to a certain degree limiting himself by denying oil paint its full power – so completely exploited in earlier years – the scale on which Turner could realize his visions of light and atmosphere was vastly enhanced through the use of canvas. A number of the later, exhibited, canvases acquired some notoriety during Turner's lifetime. This was principally because of his activities on Varnishing Days at the Royal Academy exhibition: he would often work up, in the exhibition room, what an artist on one occasion called 'a mere daub of several colours' – of which, perhaps, *Sunrise* might stand as an example – into a finished picture of considerable force.

Slavers Throwing overboard the Dead and Dying – Typhon (*sic*) Coming on

CANVAS, 91 x 138 CM. EXHIBITED 1840. BOSTON, MUSEUM OF FINE ARTS (HENRY LILLIE PIERCE FUND)

Exhibited with the following lines from Turner's own poem, the 'Fallacies of Hope', lines which, in their turn, relate to an incident described in Thomson's *The Seasons*:

Aloft all hands, strike the top-masts and belay;
Yon angry setting sun and fierce-edged clouds
Declare the Typhon's coming.
Before it sweeps your decks, throw overboard
The dead and dying — ne'er heed their chains
Hope, Hope, fallacious Hope!
Where is thy market now?

The picture was bought by John Ruskin's father, for two hundred and fifty guineas, and it was Ruskin who considered that it contained 'the noblest sea that Turner has ever painted . . . and, if so, the noblest certainly ever painted by man.'

A work which might perhaps be tentatively associated with the subject matter of *Slavers* – the *Sunrise with Sea Monsters* (Plate 47) – is in fact probably of a slightly later date, *c.*1845.

Fig. 37 Boccaccio Relating the Tale of the Birdcage

CANVAS, 122 x 90.5 CM. EXHIBITED 1828. LONDON, TATE GALLERY

Fig. 38 A Country Blacksmith Disputing upon the Price
of Iron, and the Price Charged to the Butcher
for Shoeing his Poney

OIL ON PANEL, 57.5 x 80.5 CM. EXHIBITED 1807. LONDON, TATE GALLERY

Peace — Burial at Sea

CANVAS, 87 x 86.5 CM. EXHIBITED 1842. LONDON, TATE GALLERY

With the death of the artist Sir David Wilkie, at sea, in
1841, it was generally agreed that Britain had lost one of the
outstanding painters of the age. Accounts of the 'last sad of-
fice of committing his body to the deep' were reported in
the newspapers in early June and Turner's picture was pro-
bably commenced soon after. As a tribute to a fellow artist
it is not, in fact, unique in Turner's *oeuvre*: in 1807 he had
exhibited *A Country Blacksmith Disputing upon the Price of
Iron* (Fig.38) which had undoubtedly been inspired by a
painting of Wilkie's shown the year before, and, in 1828,
Turner had painted 'in avowed imitation' of Thomas
Stothard *Boccaccio Relating the Tale of the Birdcage.*
(Fig.37). In the case of Wilkie particularly, comparisons
had actually been made between his artistic development
and Turner's – that Wilkie, like Turner, 'had deviated
. . . from the right path which he was once so far advanced
in'. The subject of *Burial at Sea* seems to coincide peculiar-
ly with Turner's own romantic concept of the artist as hero
– which ranged from his reported wish to be buried in one
of his own paintings, *Dido Building Carthage* (Plate 11), to
his role in *Snow Storm: Steam-Boat off a Harbour's Mouth*
(Plate 45). Significantly, the companion work to *Peace*, and
exhibited alongside it, was *War. The Exile and the Rock
Limpet,* which depicted Napoleon on St Helena.

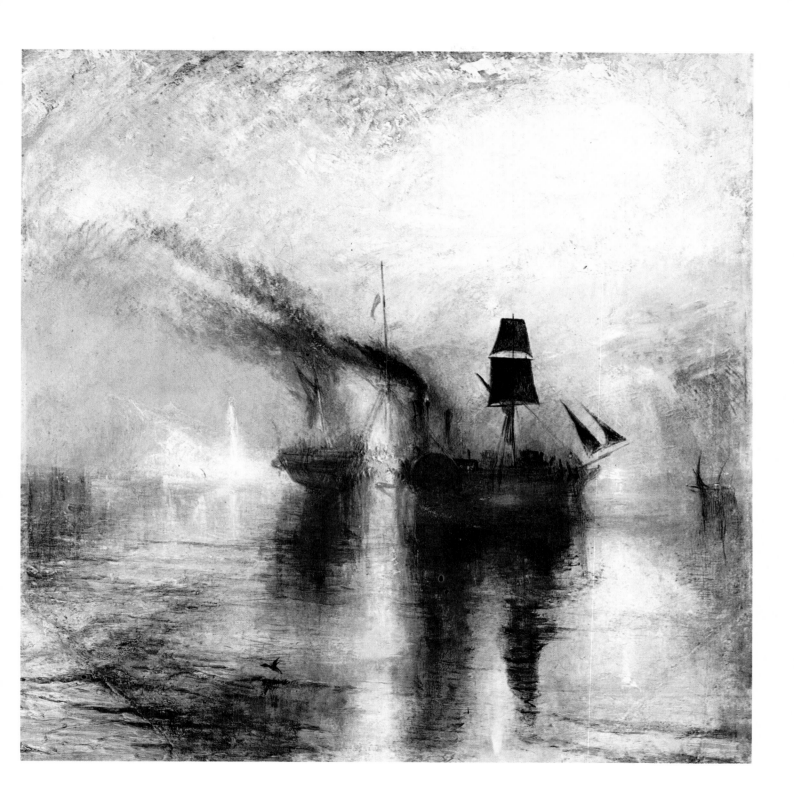

45

Snow Storm – Steam-Boat off a
Harbour's Mouth Making Signals in
Shallow Water, and Going by the Lead.
The Author was in this Storm on the
Night the Ariel Left Harwich

CANVAS, 91.5 x 122 CM. EXHIBITED 1842. LONDON, TATE GALLERY

Turner is reported as saying of this picture and the storm
which it represents '. . . I got the sailors to lash me to the
mast to observe it; I was lashed for four hours, and I did not
expect to escape, but I felt bound to record it if I did.' Des-
pite the apparently authentic autobiographical note –
which recalls, for example, *Calais Pier* (Plate 4) – it has
never been established definitely to what extent the work
was based on actual experience. The evidence would sug-
gest that it is perhaps a conflation of Turner's own sea-
going experiences and his familiarity with well-known in-
stances in which earlier painters had observed and recorded
storms at sea at close quarters.

In answer to a criticism that the picture looked like
'soap-suds and whitewash' Turner is said to have replied
'soap-suds and whitewash! What would they have? I won-
der what they think the sea's like?'. The critic in *The
Athenaeum* of 14 May 1842 described the painting as a
'frantic puzzle.'

46

Rain, Steam, and Speed —
the Great Western Railway

CANVAS, 91 x 122 CM. EXHIBITED 1844. LONDON, NATIONAL GALLERY

Produced during the Railway Mania in England, the scene shown has been identified as the railway bridge over the River Thames at Maidenhead. George Dunlop Leslie, the artist, who watched Turner finish the picture when it was hanging in the Royal Academy – as was often his practice – wrote that Turner 'pointed out the little hare running for its life in front of the locomotive. . . This hare, and not the train, I have no doubt he intended to represent the "Speed" of his title; the word must have been in his mind when he was painting the hare, for close to it, on the plain below the viaduct, he introduced the figure of a man ploughing, "Speed the plough" (the name of an old country dance) probably passing through his brain.'

47

Sunrise with Sea Monsters

CANVAS, 91.5 x 122 CM. C.1845. LONDON, TATE GALLERY

A number of watercolours of *c.* 1835-40 include studies of fish, for example, a John Dory (Ashmolean Museum) and a Gurnard, or Gurnet (Victoria and Albert Museum), and there is a more considered *Sunset at Sea, with Gurnets* of *c.*1836 in the Whitworth Art Gallery, Manchester. The features of these fishes bear obvious similarities to the sea monsters which Turner has depicted in the *Slavers* of 1840 (Plate 43) and here in *Sunrise* where they must have played some part in inspiring the larger and more fantastic vision of this picture.

Heidelberg

WATERCOLOUR, 37 x 55 CM. C.1846. EDINBURGH, NATIONAL
GALLERY OF SCOTLAND

Turner often visited the German city of Heidelberg, pay-
ing his last visit during August and September of
1844 — the year before his final trip abroad. A large oil
painting of c.1840-5 in the Tate Gallery shows a view of
Heidelberg Castle — a popular subject with many artists.
This watercolour is the last of three related, finished ver-
sions of the same view of the city from across the River
Neckar; a 'colour beginning' of c. 1840-1 is to be found in
the Turner Bequest drawings and two other watercolours
of c. 1840 and c. 1841 also exist. Evidence of the technique
commented upon in relation to the late oils (see Plate 42)
can be seen, as also can be observed one aspect of that
single-minded development of a particular theme which is
paralleled in, and reaches it culmination with, the Venetian
and Swiss watercolours of Turner's last decade.